Donna Dewberry's

ONE Stroke™

Painting Course

PLAID®

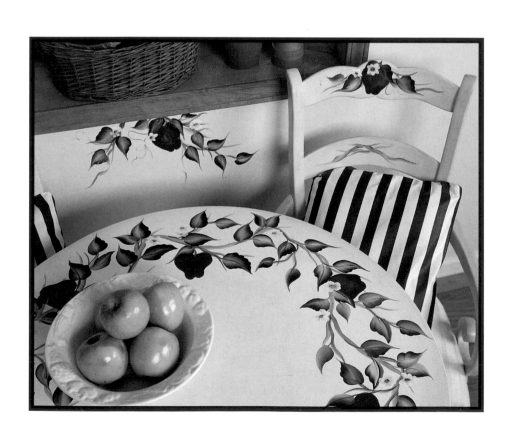

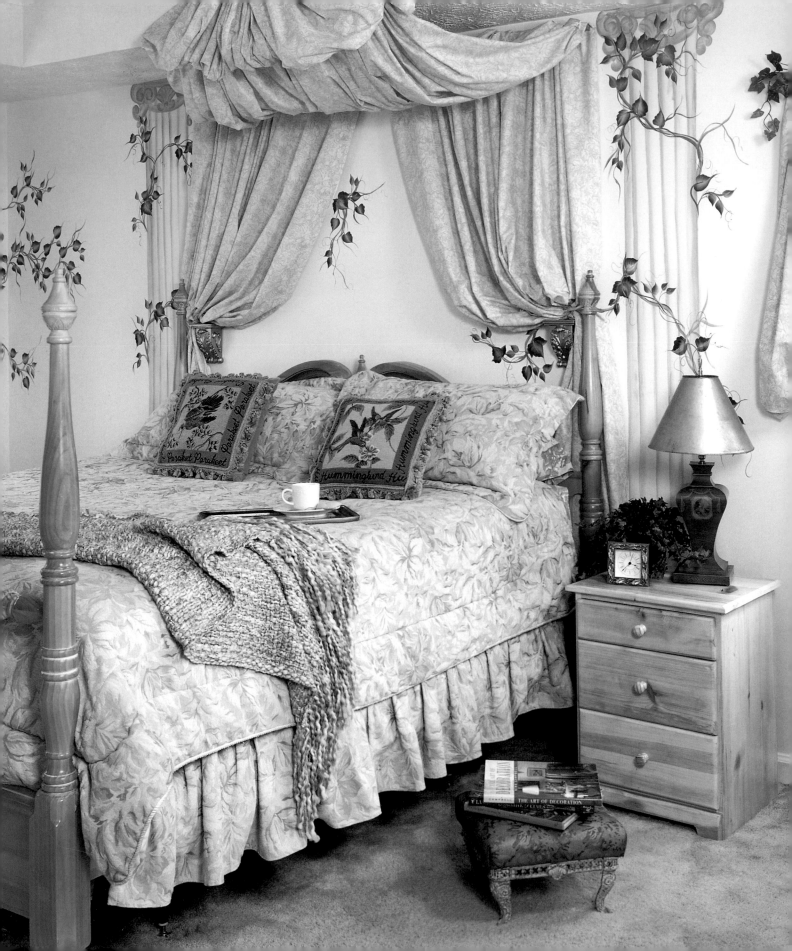

Donna Dewberry's

Painting Course

Sterling Publishing Co., Inc. New York

A Sterling / Chapelle Book

Chapelle, Ltd.:
- Owner: Jo Packham
- Editor: Laura Best
- Staff: Marie Barber, Ann Bear, Areta Bingham, Kass Burchett, Rebecca Christensen, Holly Fuller, Marilyn Goff, Shirley Heslop, Holly Hollingsworth, Sherry Hoppe, Shawn Hsu, Susan Jorgensen, Pauline Locke, Barbara Milburn, Linda Orton, Karmen Quinney, Leslie Ridenour, Cindy Stoeckl

Plaid Enterprises:
- Editor: Mickey Baskett
- Staff: Jeff Herr, Laney McClure, Susan Mickey, Dianne Miller, Jerry Mucklow, Phyllis Mueller, Susanne Yoder

If you have any questions or comments contact:
Chapelle, Ltd., Inc., P.O. Box 9252, Ogden, UT 84409
(801) 621-2777 • (801) 621-2788 Fax
- chapelle@chapelleltd.com • website: chapelleltd.com

Library of Congress Cataloging-in-Publication Data

Dewberry, Donna S.
 Donna Dewberry's one stroke painting course.
 p. cm.
 "Plaid."
 "A Sterling/Chapelle book."
 Includes index.
 ISBN 0-8069-1875-6
 1. Acrylic painting–Technique. 2. Decoration and ornament.
 I. Plaid Enterprises. II. Title. III. Title: One stroke painting
 course.
 TT385.D484 1998
 745.7'23–dc21 98-40843
 CIP

10 9 8 7 6 5 4 3

Published by Sterling Publishing Company, Inc.
387 Park Avenue South, New York, NY 10016
©1999 by Chapelle Ltd.
Distributed in Canada by Sterling Publishing
c/o Canadian Manda Group, One Atlantic Avenue, Suite 105
Toronto, Ontario, Canada M6K 3E7
Distributed in Great Britain and Europe by Cassell PLC
Wellington House, 125 Strand, London WCR2 0BB, England
Distributed in Australia by Capricorn Link (Australia) Pty Ltd.
P.O. Box 704, Windsor, NSW 2756 Australia
Printed in China
All Rights Reserved

Sterling ISBN 0-8069-1875-6 Trade
 0-8069-1975-2 Paper

About the Author

Donna Dewberry resides in central Florida with her husband Marc and three of their seven children. As the children grow up and leave the nest, the house seems to be getting larger, and there are times when it's still daylight outside and things are quiet enough for Donna to sit down and paint. That's a change from the way things were, when Donna never painted before 10 p.m. and she was always on the go. There are times when she misses the action, but Donna has fond memories of the special times when she spent those late evenings at her painting table.

Donna's children are the real motivation behind her painting. They have always been the center of her life, and the reason she began painting was to allow herself some time for personal enrichment. (Sounds good, doesn't it?) After a long day of soccer, cheerleading, gymnastics, football, baseball, basketball, carpooling (taxi service, no pay), and other assorted activities, Donna would retire to her table and paint. She taught herself through trial and error. Donna will readily tell you the story of her success is something that could happen to anyone. It's a Cinderella kind of story—except in Donna's case, the paintbrush fit her hand, perfectly.✳

This book brings together some of Donna Dewberry's most inspired home decor projects. Inside are step-by-step instructions, color worksheets, and patterns to help you create beautiful painted items, such as plates, planters, boxes, and vases, on a variety of surfaces including wood, tin, clay, and glass.

The real beauty of these projects is in the simplicity of the painting technique. Using Donna's One Stroke™ technique means no more blending paint colors. As you will learn in the following pages, most design elements require only a well-loaded brush and one stroke for completion. This is due to Donna's unique method of loading a flat brush with paint. It achieves a perfect blend of two colors in the middle of the brush while maintaining the true colors on either side. The result is an automatic blending of color.

Most supplies needed for the projects in this book can be found at local arts and crafts stores. Acrylic, water-based paints are used in all projects, and with the addition of a few brushes, you're ready to paint!

One of the wonderful things about this book is that there are so many designs to choose from. You can paint lush leaves, vibrant flowers, berries and other fruit; or you may choose some of Donna's fun Christmas projects. There is also a chapter on painting entire rooms! There is truly something for everyone.✳

Contents

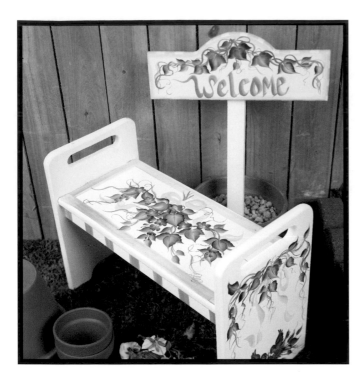

Contents

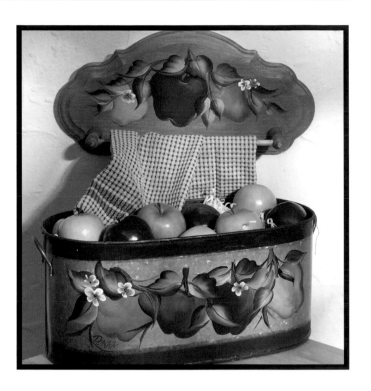

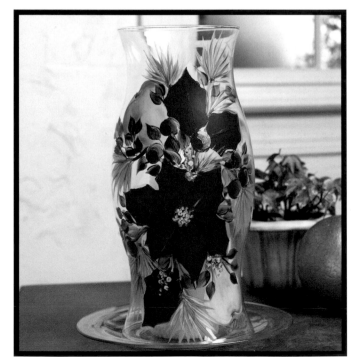

General Supplies

Paint:

Acrylic paints are high quality, bottled acrylic colors. Their rich, creamy formulation and long open time make them perfect for decorative painting. They are offered in a wide range of premixed colors and are great for blending, shading, and highlighting. They are also available in metallic colors. The sparkle and jewel tones of these acrylics add the perfect festive touch to your painting. Cleanup is easy with soap and water.

Floating medium is used to thin paint without thinning the paint's consistency, simplifying even the most difficult painting techniques. Using floating medium and paint is easier than using water and paint because there is more control and the medium does not run like water.

Glass and tile painting medium is used with acrylics to paint glass and ceramic surfaces. The medium allows better control on slick surfaces and increases durability.

Textile medium is used with acrylics for permanent, washable use on fabric.

Painting Mediums:

Antiquing medium is used to imitate the old, gently-used look of antique furniture.

Extender for acrylic paint is used to increase drying time and transparency when blending, floating, washing colors, and faux finishing.

Brushes:

With the easy One Stroke™ techniques, you do not need a lot of brushes. This book uses the following flat, liner, and scruffy brushes.

Flat brushes used for the projects in this book are ¾", and sizes #2, #6, and #12. The brush used depends on the size of the design.

Liners used consist of sizes #1 and #2. These brushes are used to make curlicues and other fine details.

Scruffy brushes are used in a pouncing motion to create effects, such as moss, greenery, and bushes.

Practice and Teaching Guides:

The blank reusable teaching guide, available at craft stores in the One Stroke™ product line, is an excellent way to practice a stroke or design before painting the project. They are specially laminated worksheets to allow practicing strokes on top of already painted designs. While paint is still wet, wipe the surface clean to practice again and again.

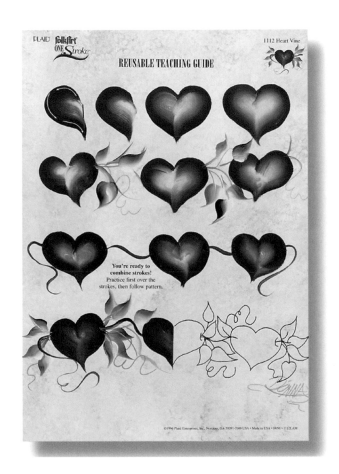

Sealers:

Acrylic **sealers** should be used to protect the project after it is finished and the paint is dry. Sealers come in a matte, gloss, or satin finish. Choose a sealer that is nonyellowing and quick-drying. Apply two or three coats, following manufacturer's instructions.

Outdoor varnish should be used if the project will be placed outdoors. Varnishes come in matte, gloss, or satin finish. Apply two or three coats after paint has dried for 48 hours, following manufacturer's instructions.

Stencils:

Reduced-size patterns are provided for the stencils used in this book, but you may wish to purchase them precut.

There are a variety of special precut stencils available at local arts and crafts stores that provide perfect backgrounds for decorative painting, block printing, or stamping.

Have fun experimenting with stencil designs to create fences, planters, bricks and cobblestone, or birdhouses—then embellish these elements with decorative painting. The possibilities are endless!

Other Supplies:

• **Aerosol spray paint:** use color listed in project instructions for base-coating tin and clay.

• **Brush cleaner:** use a liquid solution for cleaning and conditioning brush bristles.

• **Container of water:** use to rinse brushes.

• **Disposable paint palette:** use a disposable plate or palette to load brushes and mix paints.

• **Masking tape:** use to hold patterns in place while transferring to a project surface.

• **Paper towels or clean cloth rag:** use to wipe and dry brushes.

• **Rubbing alcohol:** use to clean glass surfaces before painting.

• **Sandpaper:** use to prepare wood surfaces and smooth raised grain between base-coats.

• **Tack cloth:** use to wipe dust after sanding.

• **Tracing tools:** use tracing paper and pencil to trace patterns from pattern sheets provided in this book.

• **Transfer tools:** use transfer paper and stylus to transfer patterns onto project surfaces.

• **Vinegar and damp cloth:** use to clean tin pieces before painting.✷

General Instructions

CARE & CLEANING OF BRUSHES

Proper care and cleaning make brushes last longer and perform better.

Care of Scruffy Brushes:
• Remove a scruffy brush from its package and fan bristles out to sides to create an oval shape. Wet brush and pounce it on a hard surface. Dry with paper towels.

• Be certain brush is dry before painting. Water can be trapped in ferrule and dilute paint.

• Pounce scruffy brush on a hard surface after cleaning and dry completely with paper towels. Fan bristles into an oval shape to store.

Cleaning and Care of Brushes:
• Thoroughly rinse brush with water.

• Squeeze brush cleaner into bristles and work it in with fingers all the way to the ferrule. Rinse with water. Repeat if necessary.

• Dry bristles on a clean, cloth rag or paper towel; shaping bristles while drying them. Leaving a small amount of moisture in bristles will not harm them.

Tips:
• Avoid allowing paint to dry in brush.

• Occasionally rinse bristles with water while painting.

• Store brushes in a container that allows them to retain their form and be separated from each other.

• Pat bristles on a nonperfumed, nondeodorant bar of soap to help them keep their shape. Rinse before painting again.

PRACTICE YOUR STROKES

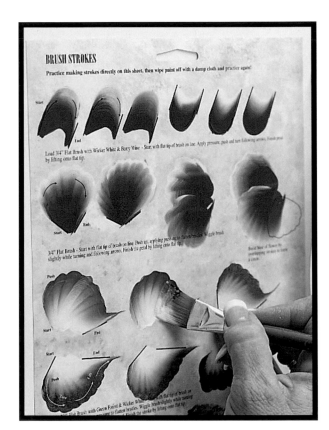

Practice brush strokes and design painting directly on surface of reusable teaching guide.

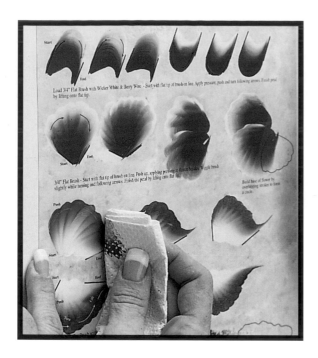

While paint is still wet, wipe off teaching guide with a damp cloth. It's ready to use again.

• **Option 1:** Create a teaching guide with 8½" x 11" clear, acetate sheets. Place acetate over color work-sheets and secure with tape. After practicing strokes, wipe off and start again.

• **Option 2:** Make a color copy of worksheets in this book. Cover both sides of copy with clear laminate. Paint strokes directly on top of laminated worksheets.

• **Option 3:** Available in the One-Stroke™ product line are color teaching guides that are specially laminated to be used again and again.

USING PATTERNS

Using pencil, trace patterns onto tracing paper. Using a copy machine, reduce or enlarge pattern to fit project surface. Position pattern on project surface and secure with tape. Place transfer paper between pattern and surface. Using a stylus, lightly trace pattern lines. It is not necessary to transfer every detail—it is more important to trace main outlines of pattern.

COMPLETING A PROJECT

• Prepare surface by cleaning and sanding.

• Base-coat surface if directed to do so in individual project instructions. Allow sufficient drying time between coats. You may need to lightly sand surface before applying another coat.

• *Option:* Antiquing is a good way to tone down the stark look of a surface and add design and color. Stroke a slightly dampened cellulose sponge in antiquing medium and rub over project surface in a circular motion. Light pressure creates a lighter shade; heavy pressure creates a darker shade. Let dry.

• Study painting worksheets in this book.

• Trace and transfer pattern onto surface.

• Paint larger flowers or buds first, and then fill in with leaves.

• Paint leaves and florals by building one stroke at a time.

• Make certain to add your signature.

• Let dry. Apply a finish as directed in individual project instructions.

PAINTING ON GLASS & GLAZED CERAMIC

• Clean surface with rubbing alcohol.

• Stir—*do not shake*—glass & tile medium.

• Apply medium to entire surface of design. On a glass piece, if possible, place pattern behind glass so medium can be applied without tracing. Let medium dry completely.

• Paint design over dried medium. Let dry.

• Apply another coat of glass & tile medium over painted design or to entire surface. For best results, allow to cure for two weeks .✳

Loading a Liner

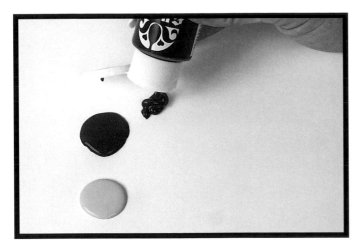 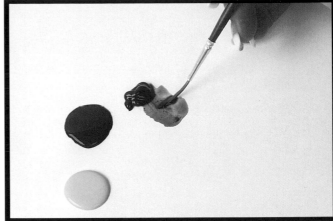

1 Squeeze a small puddle of paint onto palette. Dilute at edge with water to an ink-like consistency, allowing paint to flow freely from brush.

2 Stroke liner along edge of paint puddle, pulling paint into brush. Stroke brush on palette to blend paint into bristles. Load liner fully, up to ferrule.✳

Loading a Flat Brush

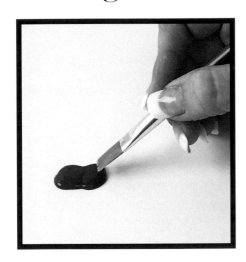 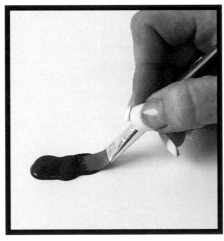 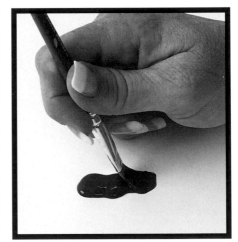

1 Squeeze a small puddle of paint onto palette. Place brush at edge of puddle.

2 Pull paint out from edge of puddle, loading one side of brush.

3 Turn brush over and repeat to load other side. Brush back and forth on palette to fully load all bristles.✳

Double-loading a Flat Brush

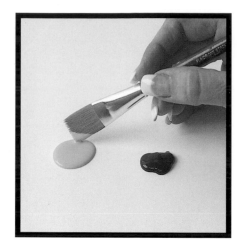

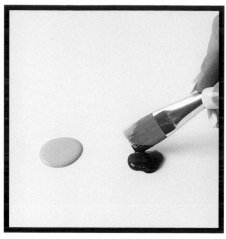

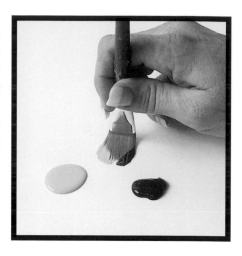

1 Squeeze two small puddles of paint onto palette. Dip corner of brush into first color at edge of puddle.

2 Turn brush over and dip other corner into second color in the same manner.

3 Notice the "V" shape created on the brush by the two colors of paint.

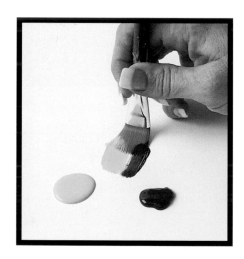

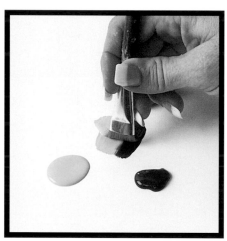

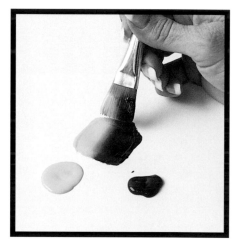

4 Pull brush onto palette to begin moving paint into the bristles.

5 Turn brush over and pull through the same strokes on palette to work paint into both sides of the brush.

6 While brushing back and forth, pick up more paint on corners two or three times. Continue until bristles are loaded two-thirds of the way up toward the ferrule.✻

Multiloading a Flat Brush

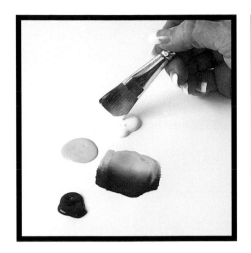 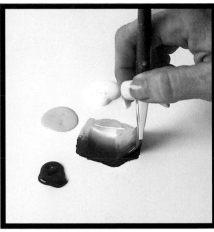 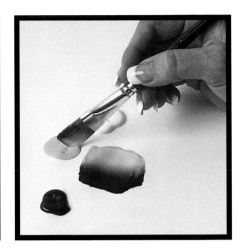

1 Double-load brush, then dip corner of the light side into a still lighter color.

2 Brush out onto area where you brushed back and forth for double-loading to blend lighter color into bristles.

3 To pick up more paint, dip each corner of brush into paint, but do not brush back and forth as if loading.✻

Preparing a Scruffy Brush

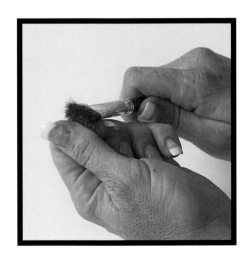 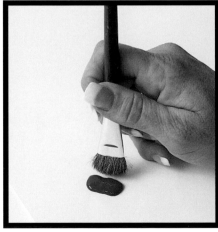 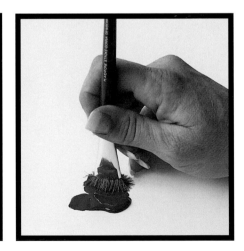

1 Use thumb to fan out bristles of brush.

2 Hold brush at edge of puddle of paint on palette.

3 Push brush straight down into puddle of paint.✻

Multiloading a Scruffy Brush

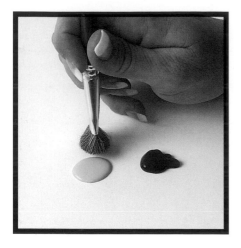

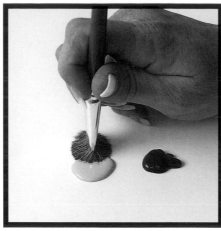

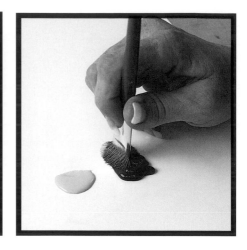

1 Hold brush at edge of puddle of first paint color on palette.

2 Push brush straight down into puddle of first color.

3 Turn brush to another area and push it into edge of second color puddle.

4 Turn brush around and pounce it into first color again.

5 Look at brush to see that bristles are loaded half with each color. Do not overblend to mix colors.

6 If desired, dip brush into a third color.✳

Using a Scruffy Brush

1 To make grass and moss, multiload scruffy brush with Green Forest, Maple Syrup, and Wicker White. Hold brush in an upright position and push down on bristles.

2 Move brush along area to be colored and pounce. Do not twist brush.

3 To make wisteria, double-load brush with Dioxazine Purple and Wicker White. Pounce a half circle.

4 Pounce a smaller circle for a second layer.

5 Begin to lean brush while pouncing.

6 Taper off pounced area to end.✳

Scruffy Brush Worksheet

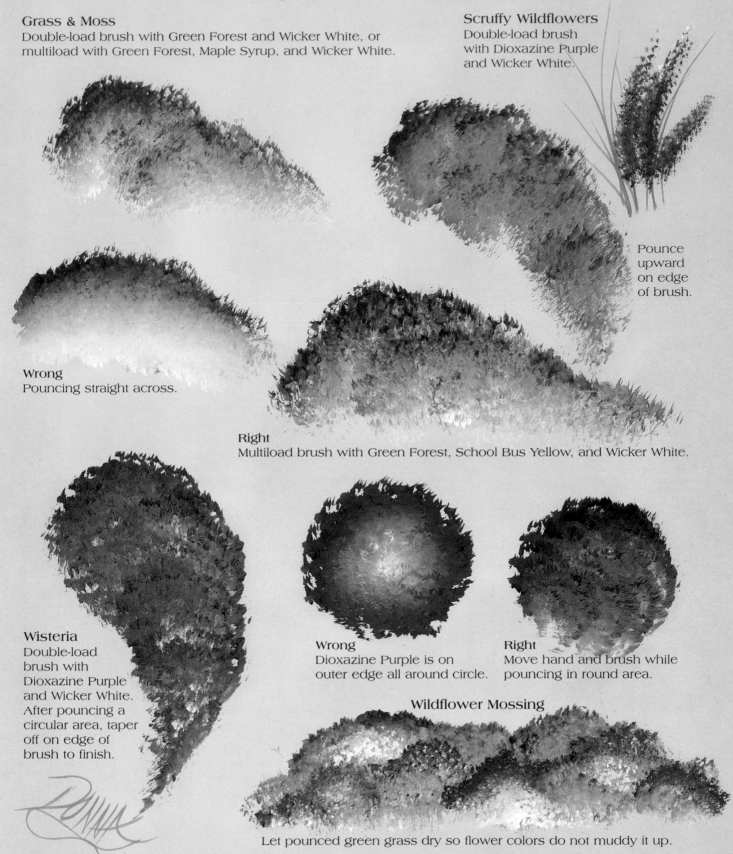

Grass & Moss
Double-load brush with Green Forest and Wicker White, or multiload with Green Forest, Maple Syrup, and Wicker White.

Scruffy Wildflowers
Double-load brush with Dioxazine Purple and Wicker White.

Pounce upward on edge of brush.

Wrong
Pouncing straight across.

Right
Multiload brush with Green Forest, School Bus Yellow, and Wicker White.

Wisteria
Double-load brush with Dioxazine Purple and Wicker White. After pouncing a circular area, taper off on edge of brush to finish.

Wrong
Dioxazine Purple is on outer edge all around circle.

Right
Move hand and brush while pouncing in round area.

Wildflower Mossing

Let pounced green grass dry so flower colors do not muddy it up.

Floating

1 Floating is done only with a side-loaded brush, using a floating medium with the paint. Squeeze a puddle of floating medium onto palette.

2 Dip corner of brush into floating medium. Brush back and forth on palette to work floating medium into all bristles of brush.

3 Pull corner of brush through paint color on palette, pulling from edge of the puddle. Brush back and forth in this spot at edge of puddle to blend color into bristles. Flip brush to back side and brush back and forth in same spot. Color will be on only half of brush and fade out at center.

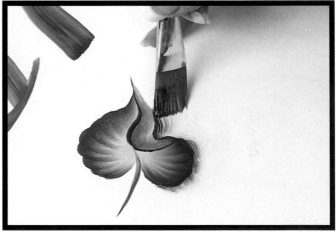

4 With paint side of brush next to design, simply pull brush along edge of the design. Notice how the color fades.✳

How to Paint Leaves

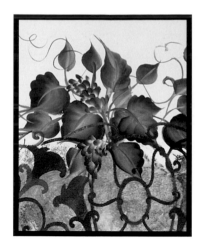

This chapter gives instructions on the techniques of painting a variety of leaves. It shows how to paint leaves for sunflowers, daisies, fruit, and roses, as well as steps for painting vines, stems, and branches. With color worksheets and step-by-step illustrations, painting could not be easier.✻

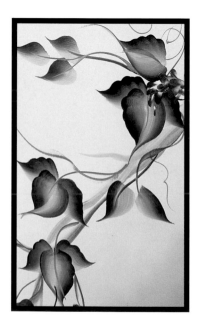

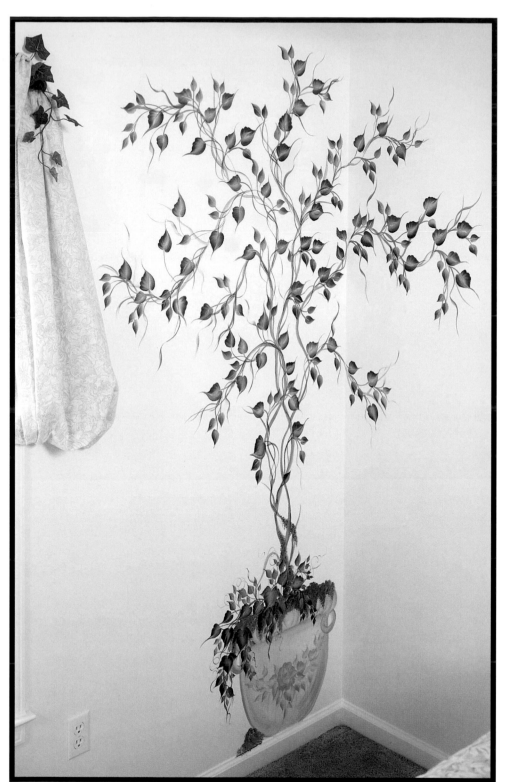

Painting a Scallop-edged Heart Leaf

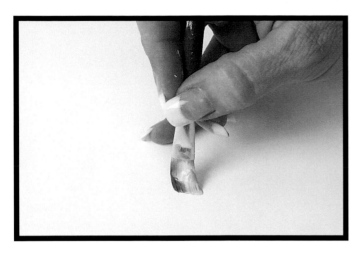

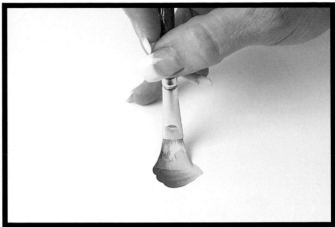

1 Using a loaded flat brush, begin on chisel edge and make one-half of leaf at a time.

2 Pull brush, then apply pressure to push down and wiggle the brush as you pull the stroke to make scalloped edge of leaf.

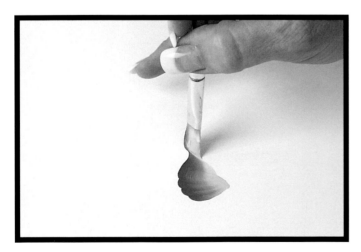

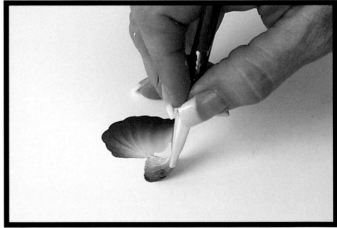

3 Pull brush up to end on chisel edge to make leaf tip.

4 Make second half of leaf by turning paintbrush and continuing in opposite direction.✻

Painting a Smooth-edged Fruit Leaf

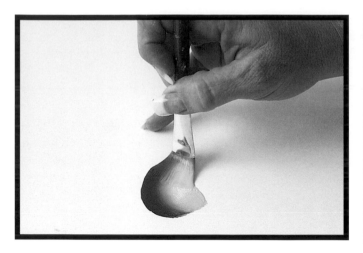

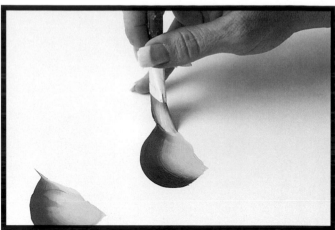

1 Double-load flat brush and press down on chisel edge.

2 Curve stroke and pull brush up.

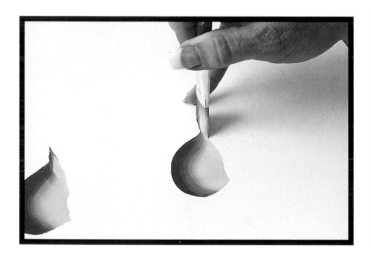

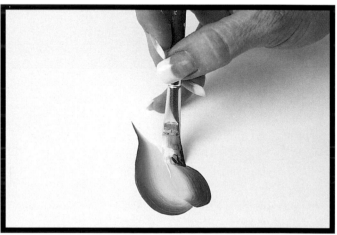

3 End on chisel edge for first side.

4 To make second half of leaf, begin with brush forming a "V" shape with first half. Pull, push, wiggle, and lift to end.✳

Painting an All-in-One Leaf

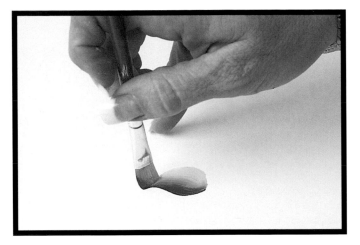

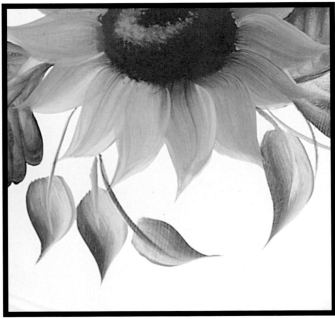

1 Double-load a flat brush. Make a One Stroke™ leaf, ending on chisel edge.

2 Pull brush back through leaf on chisel edge.

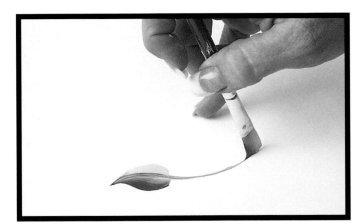

3 Continue past base of leaf on chisel edge to make stem.❄

Completed all-in-one leaf.

Painting a Sunflower & Daisy Leaf

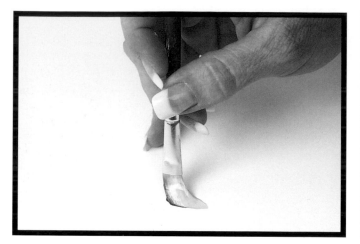

1 Begin on chisel edge.

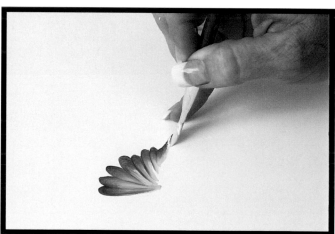

2 Make a C-stroke.

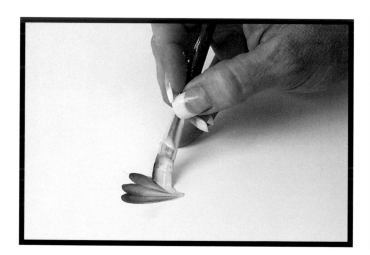

3 Continue pulling C-strokes, working with an "m" motion.

4 End on chisel edge.✳

Painting a Turned Leaf

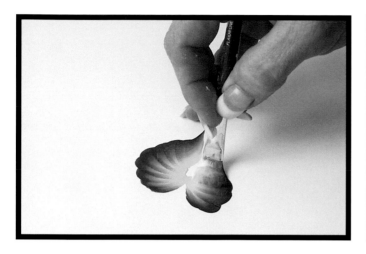

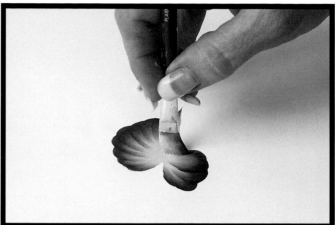

1 Refer to Painting a Scallop-edged Heart Leaf on page 21. Using a flat brush, make a scallop-edged heart leaf.

2 Pull brush up onto chisel edge.

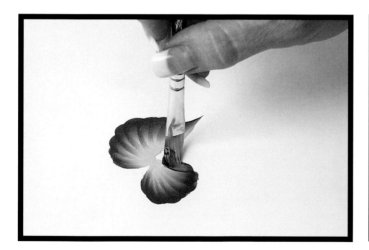

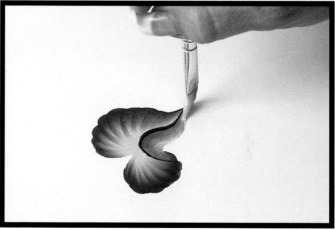

3 Pivot and flip brush.

4 Pull brush toward point of leaf with a comma stroke.✳

Leaf Worksheet #1

Scallop-edged Heart Rose Leaf

Double-load brush with Green Forest and Wicker White.

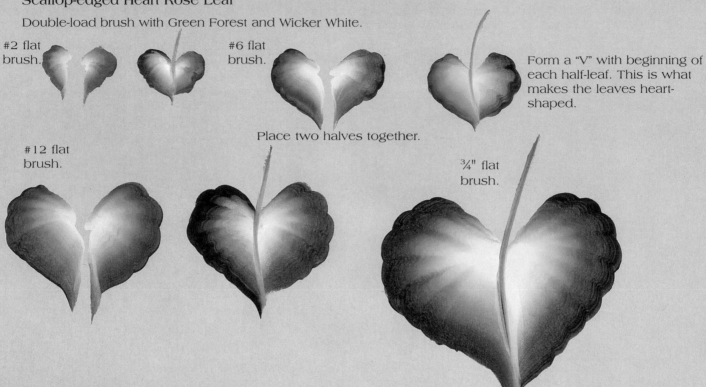

#2 flat brush.

#6 flat brush.

Place two halves together.

Form a "V" with beginning of each half-leaf. This is what makes the leaves heart-shaped.

#12 flat brush.

¾" flat brush.

Ruffle-edged Floral or Fruit Leaf

Double-load #12 flat brush with Green Forest and School Bus Yellow. Press and wiggle. Finish with a chisel edge stem.

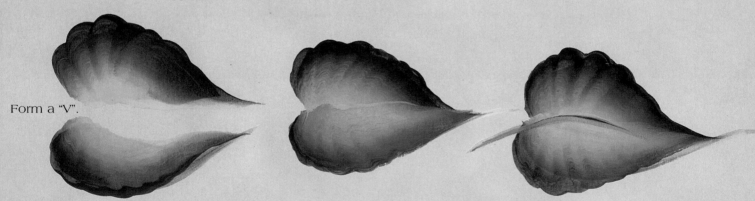

Form a "V".

All-in-One Leaf

Double-load #12 flat brush with Green Forest and Wicker White. Start on chisel edge, press and turn while lifting brush to tip of leaf, turning green side to tip.

Slide green side back through center of leaf for stem.

Press and wiggle to tip. On chisel edge, slide brush back down center of leaf.

Leaf Worksheet #2

Sunflower/Daisy Leaf
Double-load flat brush with Green Forest and Wicker White.

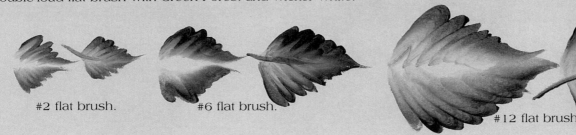

#2 flat brush.

#6 flat brush.

#12 flat brush.

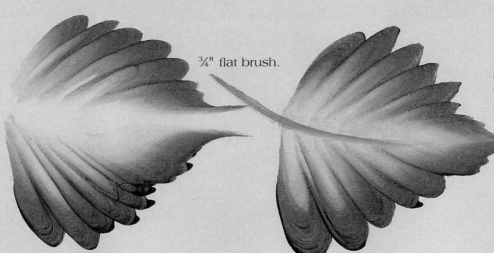

¾" flat brush.

Start on chisel edge. With exaggerated movement, work back and forth with a smooth sliding motion.

Smooth-edged Fruit Leaf
Double-load ¾" flat brush with Green Forest and Wicker White.

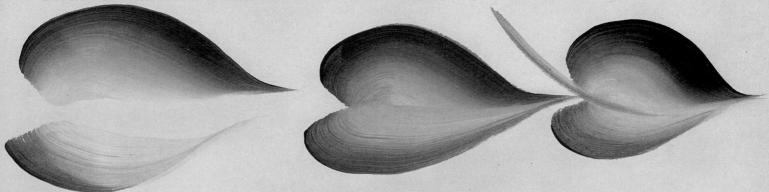

Turned Leaf
Double-load flat brush with Green Forest and Wicker White. Press, wiggle, turn, and lift to chisel edge.

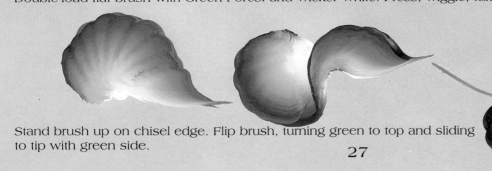

Stand brush up on chisel edge. Flip brush, turning green to top and sliding to tip with green side.

27

Painting a Chisel-edged Vine

1 Double-load brush. Hold brush on chisel edge, leading with the light color.

2 Pull wavy lines, keeping brush on its chisel edge.

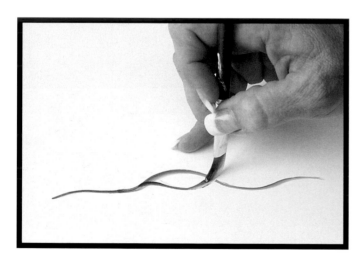

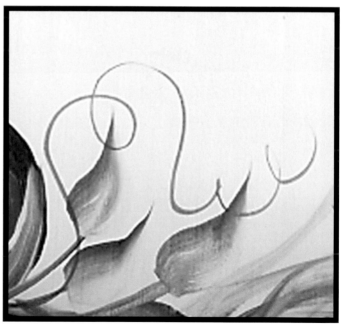

3 Pull other wavy lines, starting on original vine, but veering off while pulling brush.✳

Completed chisel-edged vine.

Painting a Chisel-edged Stem

1 Start on chisel edge of brush to pull a stem into a leaf. Start above leaf where stem will begin.

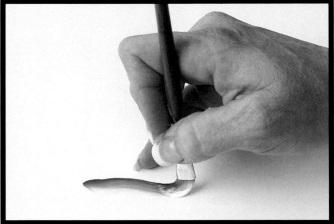

2 Pull stem stroke into leaf, moving about one-third way into leaf.❋

Painting a Chisel-edged Branch

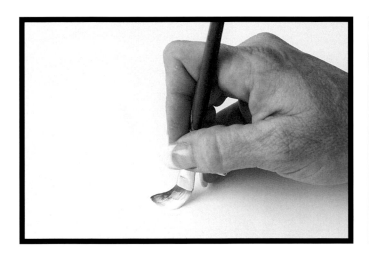

1 Double-load brush. Start by positioning brush on an angle.

2 Pull brush to create the branch.❋

Leaf & Vine Worksheet

One-stroke Leaf
Double-load #12 flat brush with Green Forest and Sunflower. Paint stem into leaf on chisel edge of brush.

Two-stroke Leaf
Double-load ¾" flat brush with Green Forest and Sunflower. Paint stem into leaf on chisel edge of brush.

Ivy Leaf
Double-load ¾" flat brush with Green Forest and Sunflower.

Small Thin Leaf
Double-load #6 flat brush with Green Forest and Sunflower.

Tall Thin Leaf
For iris and tulips.
Double-load ¾" flat brush with Green Forest and Sunflower. Begin with flat edge of brush, turn onto chisel edge, pull and turn to opposite flat edge.

Daisy Leaf
Double-load #12 flat brush with Green Forest and Sunflower.

Grass
Double-load ¾" flat brush with Green Forest and Sunflower. Leading with Sunflower edge, stroke from bottom to top on chisel edge of brush.

Trailing Flowers
Double-load #6 flat brush with Berry Wine and Wicker White. Paint each petal with a backward C-stroke. Start at tip, layering petals to form clusters.

#6 flat brush. #2 flat brush.

Small Leaf
Double-load with Green Forest and Sunflower.

Vine
Using #6 flat brush, paint on chisel edge with Green Forest and School Bus Yellow, leading with yellow.

Trims & Techniques

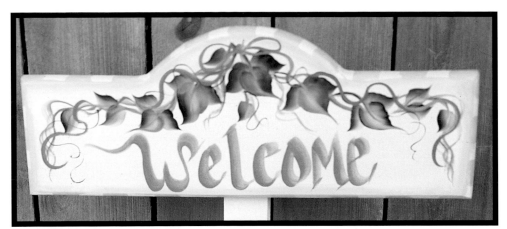

All the little secrets to painting vines, ribbons, grass, wildflowers, moss, lace, and more are revealed in this chapter. Learning these little tricks will add to the professional look of your projects.✻

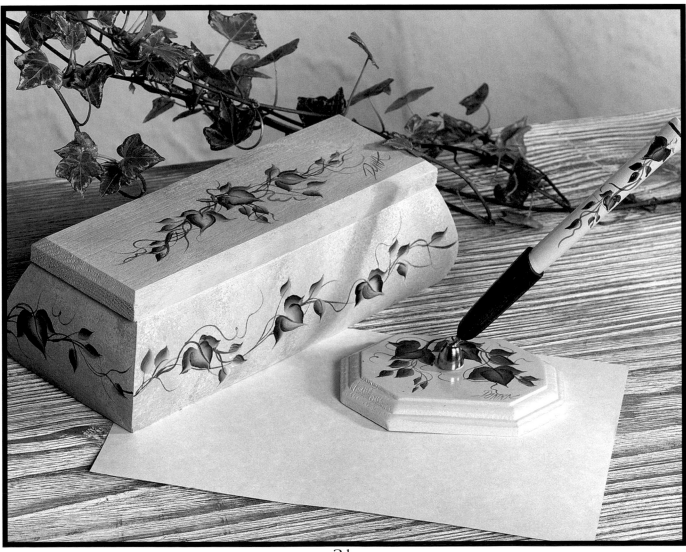

General Techniques Worksheet

Grass
Paint grass with upward chisel-edged strokes.

Inky Paint
Make paint inky by diluting with water. Using #2 liner, stroke with inky paint.

Dots
Using handle end of brush, paint dots.

Sponging
Using a sea sponge, dab paint randomly.

Spattering
Using a loaded toothbrush, pull bristles toward handle to spatter paint.

Pouncing
Using loaded scruffy brush, pounce with two colors.

Using loaded scruffy brush, pounce with three colors.

Layer Painting
Overlay patterns; paint vines first. Let dry. Trace leaves and flowers over vines; paint.

Ribbon & Lace Worksheet

Ribbon
Beginning with flat edge of brush, turn onto chisel edge. Pull and turn to opposite flat edge.

Lace
Base-coat with Wicker White.

Using #1 liner, paint "threads". Using handle end of brush, paint dots with Wicker White for knots.

Bow
Double-load ¾" flat brush with Midnight and Wicker White.

Flower Center
Using handle end of brush, paint dots.

Dot again with another color.

C-stroke Flower
Double-load ¾" flat brush with Country Twill and Wicker White. Make 5–6 overlapping petals.

Blue Flower
Double-load #12 flat brush with Night Sky and Wicker White.

Yellow Flower
Double-load #12 flat brush with School Bus Yellow and Wicker White

Completed bow.

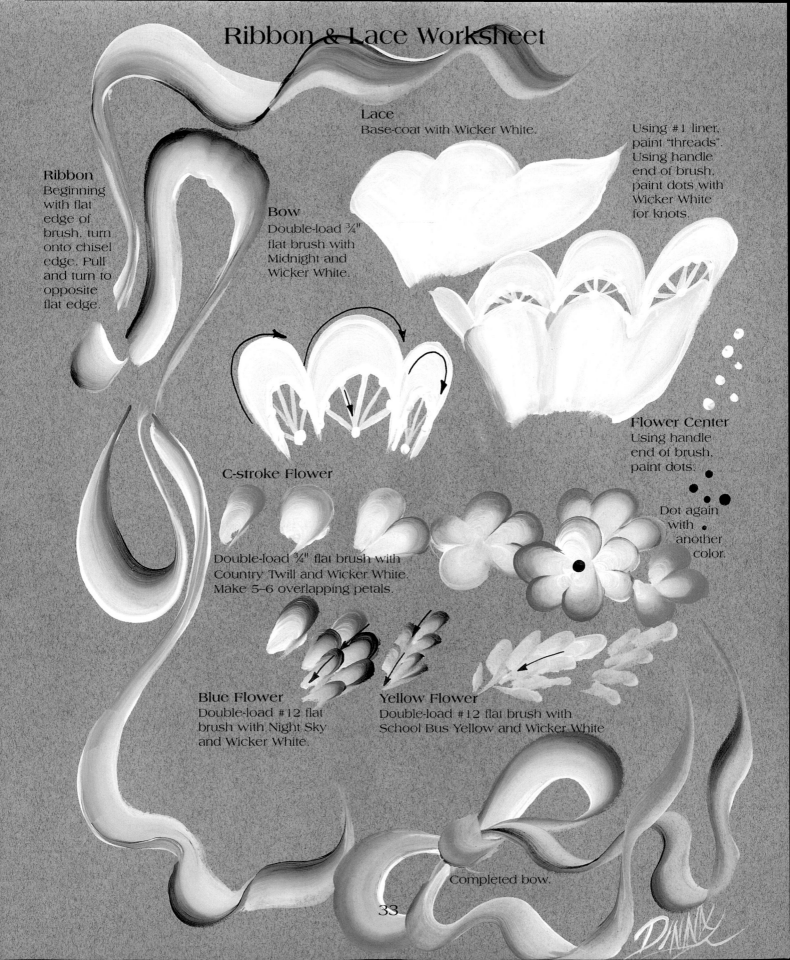

33

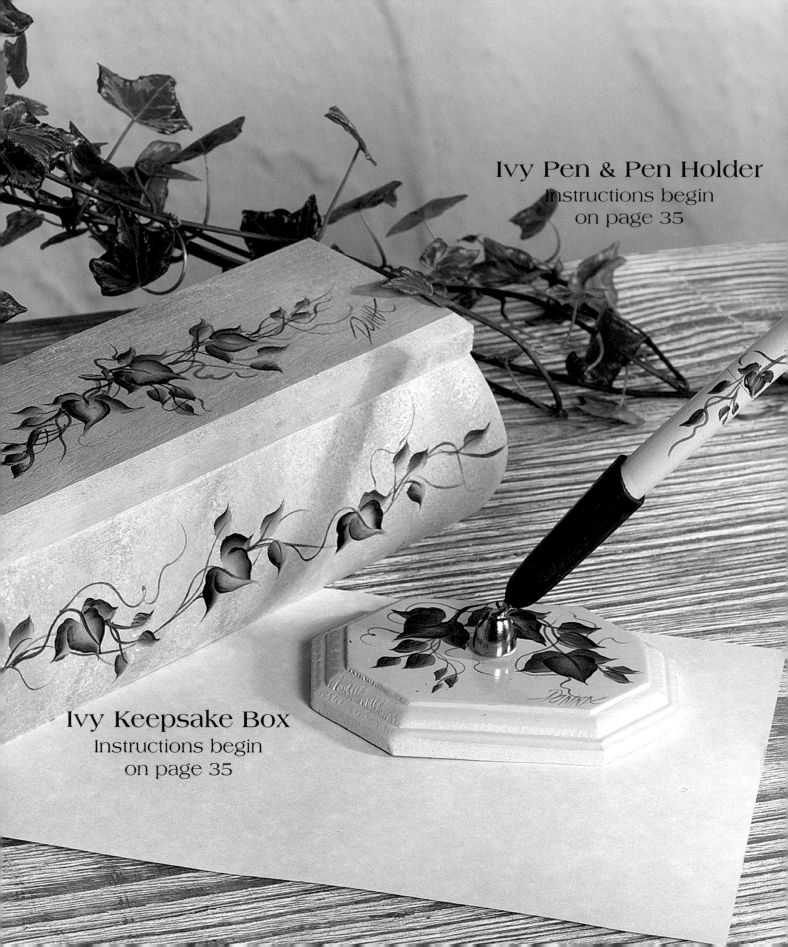

Ivy Pen & Pen Holder
Instructions begin
on page 35

Ivy Keepsake Box
Instructions begin
on page 35

Ivy Pen
& Pen Holder

Pictured on page 34

GATHER THESE SUPPLIES

Painting Surface:
Wooden pen and pen holder

Paints, Stains & Finishes:
Acrylic craft paints:
 Green Forest
 Parchment
 Wicker White
Matte acrylic sealer

Brushes:
Flat, #2, #6
Liner, #1

Other Supplies:
Sandpaper, 220 grit
Tack cloth
Tracing tool
Transfer tool

INSTRUCTIONS

Prepare:
1. Refer to General Instructions on pages 11–19. Using sandpaper, sand pen and holder. Using tack cloth, wipe away dust.

2. Using #2 flat brush, basecoat wood areas of pen and holder with Parchment. Let dry.

3. Using tracing and transfer tools, transfer Ivy Pen & Pen Holder Patterns on page 36 onto top of holder and pen.

Paint the Design:
Ivy Vines:
1. Refer to Leaf & Vine Worksheet on page 30. Using #2 flat brush, paint ivy vines with Green Forest and Wicker White.

Ivy Leaves:
1. Using #6 flat brush, paint ivy leaves with Green Forest and Wicker White.

2. Using #1 liner, paint stems into leaves with inky Green Forest.

Curlicues, Band & Name:
1. Paint curlicues, narrow band around pen, and sign your name with inky Green Forest. Let dry.

Finish:
1. Apply matte acrylic sealer.✳

Ivy Keepsake
Box

Pictured on page 34

GATHER THESE SUPPLIES

Painting Surface:
Wooden rectangular box
 with lid, 9" x 3½" x 3¼"

Paints, Stains & Finishes:
Acrylic craft paints:
 Basil Green
 Green Forest
 Maple Syrup
 Wicker White
Matte acrylic sealer

Brushes:
Flat, #2, #6
Liner, #1

Other Supplies:
Household sponge
Sandpaper, 220 grit
Tack cloth
Tracing tool
Transfer tool

INSTRUCTIONS

Prepare:
1. Refer to General Instructions on pages 11–19. Using sandpaper, sand box. Using tack cloth, wipe away dust.

2. Using #2 flat brush, basecoat box with Wicker White. Let dry.

3. Using household sponge, sponge box with Basil Green and Wicker White. Let dry.

4. Using tracing and transfer tools, transfer Ivy Keepsake Box Patterns on page 36 onto sides and top of box.

Paint the Design:
Branch & Brown Vines:
1. Refer to Leaf & Vine Worksheet on page 30. Using chisel edge of #6 flat brush, paint branch and vines with Maple Syrup and Wicker White.

Ivy Vines:
1. Using #2 flat brush, paint ivy vines with Green Forest and Wicker White.

Ivy Leaves:
1. Using #6 flat brush, paint ivy leaves with Green Forest and Wicker White.

2. Using #1 liner, paint stems into leaves with inky Green Forest.

Curlicues & Name:
1. Paint curlicues and sign your name with inky Green Forest. Let dry.

Finish:
1. Apply matte acrylic sealer.✳

Ivy Keepsake Box Side Pattern

Repeat pattern around box

Ivy Keepsake Box Top Pattern

Ivy Pen & Pen Holder Patterns

Patterns are actual size

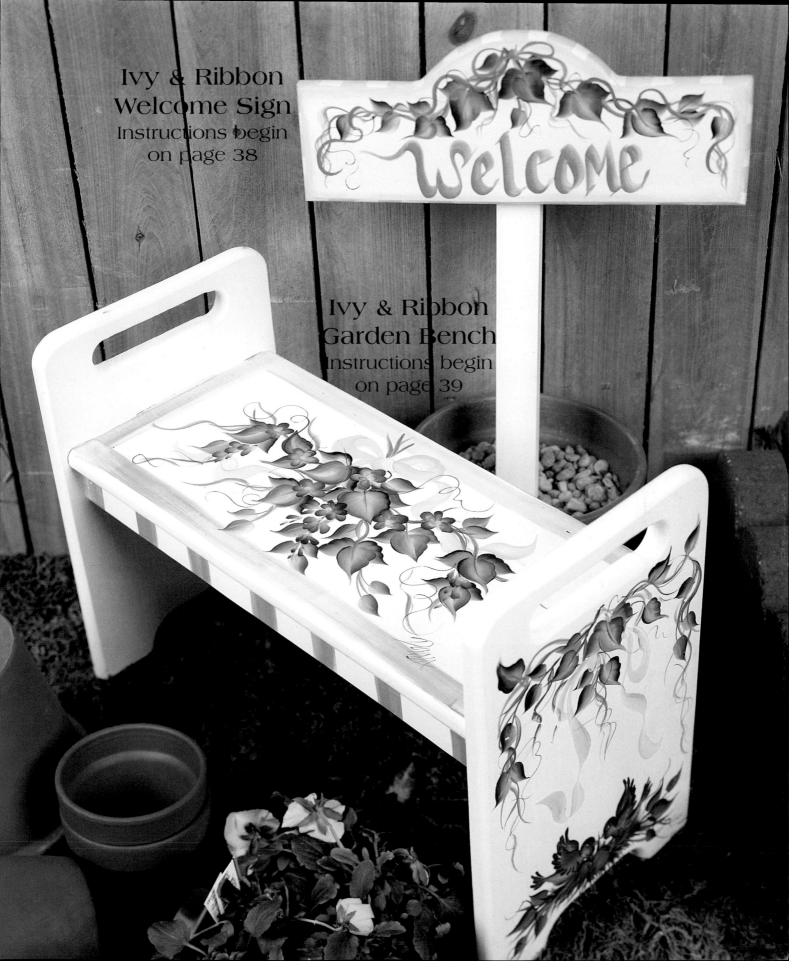

Ivy & Ribbon
Welcome Sign
Instructions begin
on page 38

Welcome

Ivy & Ribbon
Garden Bench
Instructions begin
on page 39

Ivy & Ribbon Welcome Sign

Pictured on page 37

GATHER THESE SUPPLIES

Painting Surface:
Arched-top wooden sign,
14" x 5", on a picket

Paints, Stains & Finishes:
Acrylic craft paints:
 Green Forest
 Periwinkle
 Sunflower
 Wicker White
Matte acrylic sealer
White primer

Brushes:
Flat, ¾", #12
Liner, #2

Other Supplies:
Sandpaper, 220 grit
Tack cloth
Tracing tool
Transfer tool

INSTRUCTIONS

Prepare:
1. Refer to General Instructions on pages 11–19. Using sandpaper, sand wooden sign. Using tack cloth, wipe away dust.

2. Apply white primer, following manufacturer's instructions. Let dry.

3. Using #12 flat brush, basecoat sign with Wicker White. Let dry.

4. Paint stripes around edges of sign with Sunflower. Refer to photo on page 37 as a guide for placement.

5. Paint around edges of sign with Sunflower. Let dry.

6. Using tracing and transfer tools, transfer Ivy & Ribbon Welcome Sign Pattern onto sign.

Paint the Design:
Words:
1. Using #2 liner, paint "Welcome" with Periwinkle.

Leaves & Vines:
1. Refer to Leaf & Vine Worksheet on page 30. Using ¾" flat brush, paint leaves and vines with Green Forest.

Curlicues & Name:
1. Using #2 liner, paint curlicues and name with inky Green Forest. Let dry.

Bow:
1. Using chisel edge of ¾" flat brush, paint string bow with Periwinkle and Wicker White. Let dry.

Finish:
1. Apply matte acrylic sealer.�֍

Ivy & Ribbon Welcome Sign Pattern

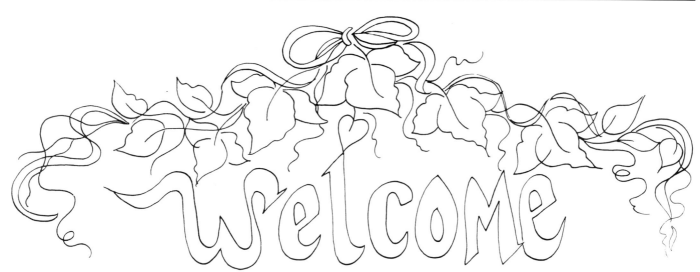

Enlarge pattern 165%

Ivy & Ribbon Garden Bench

Pictured on page 37

GATHER THESE SUPPLIES

Painting Surface:
Wooden bench,
 24" x 12" x 16"

Paints, Stains & Finishes:
Acrylic craft paints:
 Berry Wine
 Green Forest
 Licorice
 Maple Syrup
 Mint Green
 Night Sky
 Sunflower
 Wicker White
Matte acrylic sealer
White latex paint, satin finish
White primer

Brushes:
Flat, ¾", #12
Liner, #2

Other Supplies:
Sandpaper, 220 grit
Tack cloth
Tracing tool
Transfer tool

INSTRUCTIONS

Prepare:
1. Refer to General Instructions on pages 11–19. Using sandpaper, sand bench. Using tack cloth, wipe away dust.

2. Apply white primer, following manufacturer's instructions. Let dry.

3. Using #12 flat brush, basecoat bench with white latex paint. Let dry.

4. Using ¾" flat brush, paint border around edges of seat and widely spaced stripes with inky Mint Green. Refer to photo on page 37 as a guide for placement. Let dry.

5. Using tracing and transfer tools, transfer Ivy & Ribbon Garden Bench Side and Seat Patterns on pages 40 and 41 onto bench.

Paint the Design:
Vines:
1. Refer to Leaf & Vine Worksheet on page 30. Paint vines with Green Forest and Sunflower.

Ivy Leaves:
1. Paint ivy leaves with Green Forest and Sunflower.

Bows:
1. Refer to Ribbon & Lace Worksheet on page 33. Paint bows with Sunflower and Wicker White.

Flowers:
1. Paint C-strokes to form flowers with Night Sky and Wicker White.

2. Using handle end of brush, dot flower centers with Sunflower.

Birds:
1. Using chisel edge of ¾" flat brush, paint upper body with Night Sky and Wicker White, starting at top of head and ending at point of tail.

2. Repeat same stroke as before with Berry Wine and Wicker White to form lower half of bird's body.

3. Using chisel edge of brush, stroke in back wing and tail feathers with Night Sky and Wicker White.

4. Using chisel edge of #12 flat brush, paint front wing feathers with Night Sky and Wicker White.

5. Using #2 liner, paint bird's beak with Sunflower.

6. Paint bird's eye with Licorice.

Bird's Nest and Eggs:
1. Using chisel edge of #12 flat brush and leading with white end, stroke in bird's nest with Maple Syrup and Wicker White.

2. Paint eggs, layering one over another, with Night Sky and Wicker White.

Curlicues & Name:
1. Using #2 liner, paint curlicues and sign your name with inky Green Forest.

Finish:
1. Apply matte acrylic sealer.❀

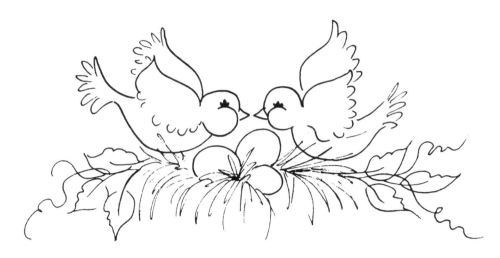

Enlarge patterns 155%

Ivy & Ribbon Garden Bench Seat Pattern

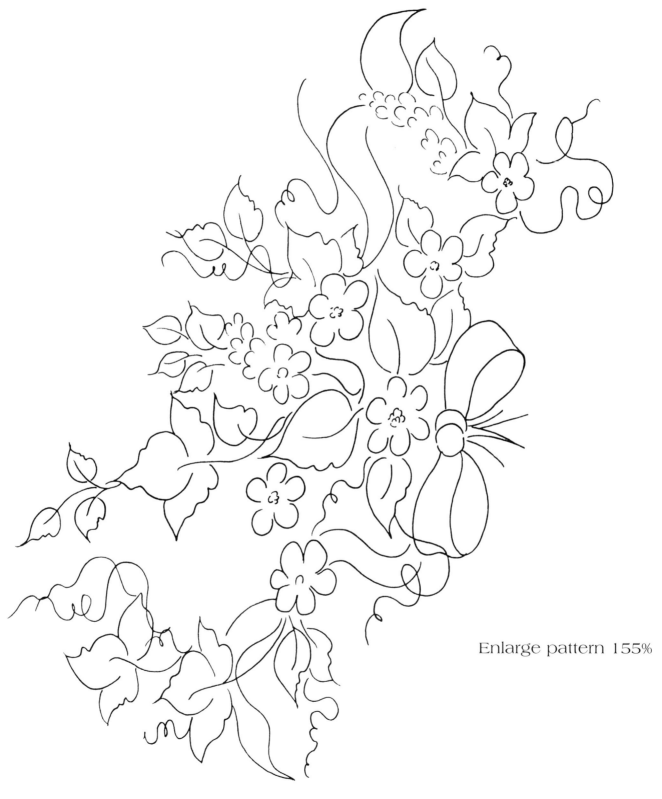

Enlarge pattern 155%

How to Paint Flowers

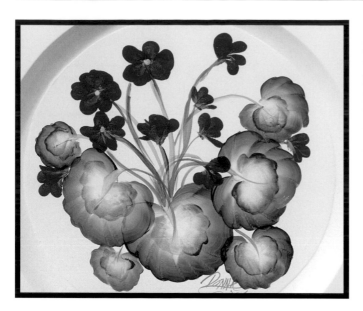

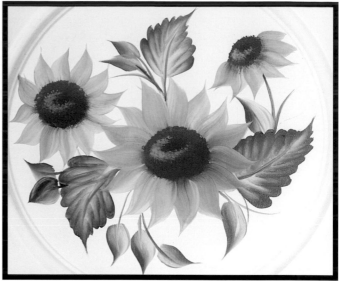

This chapter shows how to paint a garden full of flowers, such as roses, sunflowers, foxglove, morning glories, hollyhocks, and geraniums. All your favorites are here. Helpful color worksheets show how to paint plates, T-shirts, lamps, and much more! The charming flowers shown here will add the perfect look to your home decor accessories.✳

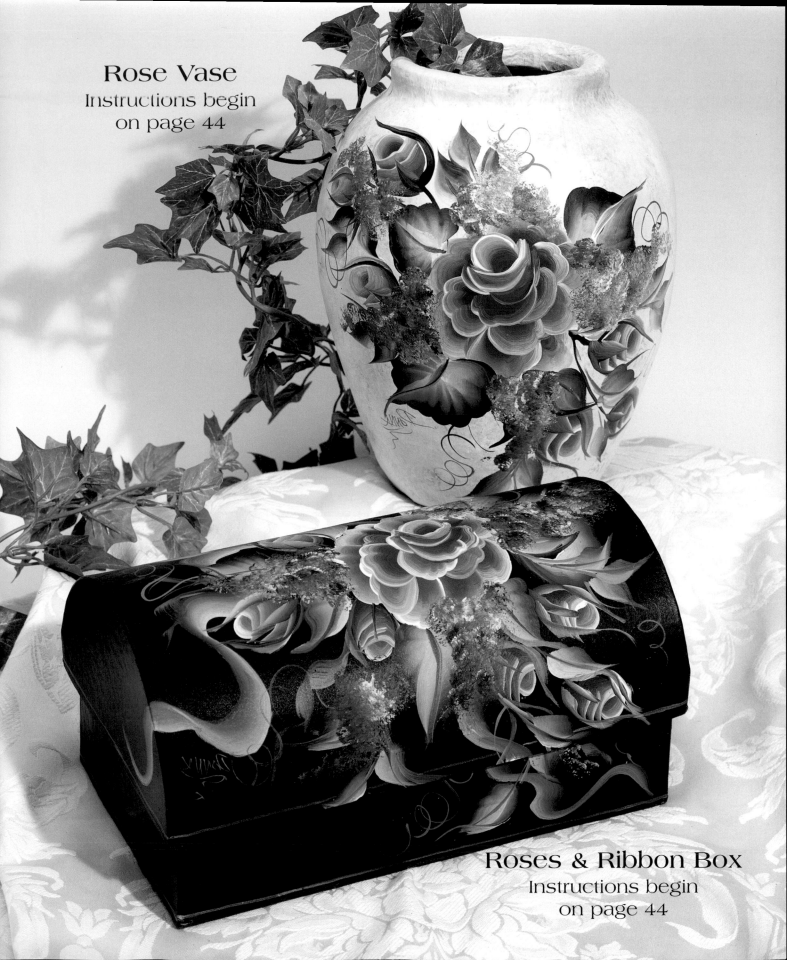

Rose Vase
Instructions begin
on page 44

Roses & Ribbon Box
Instructions begin
on page 44

Rose Vase

Pictured on page 43

GATHER THESE SUPPLIES

Painting Surface:
Papîer maché vase,
 12" x 10" dia.

Paints, Stains & Finishes:
Acrylic craft paints:
 Alizarin Crimson
 Green Forest
 Light Gray
 Prussian Blue
 Wicker White
Matte acrylic sealer
Spray paint: Wicker White

Brushes:
Flat, ¾", #12
Liner, #2
Scruffy brush

Other Supplies:
Tracing tool
Transfer tool

INSTRUCTIONS

Prepare:
1. Refer to General Instructions on pages 11–19. Spray vase with Wicker White spray paint. Let dry.

2. Using scruffy brush, lightly stipple vase with Light Gray.

3. Using tracing and transfer tools, transfer Rose Vase Pattern on page 46 onto vase.

Paint the Design:
Fully Bloomed Rose:
1. Refer to Rose Worksheet on page 48. Using ¾" flat brush, paint rose with Alizarin Crimson and Wicker White.

Rosebuds:
1. Refer to Rosebuds & Ribbon Worksheet on page 47. Using #12 flat brush, paint rosebuds with Alizarin Crimson and Wicker White.

Rosebud Bracts:
1. Using chisel edge of ¾" flat brush, paint around bud with Green Forest and Wicker White.

Leaves:
1. Refer to Leaf & Vine Worksheet on page 30. Paint leaves with Green Forest and Wicker White.

Curlicues & Name:
1. Using #2 liner, paint curlicues and name with inky Green Forest.

Wisteria:
1. Refer to Scruffy Brush Worksheet on page 18. Using scruffy brush, pounce wisteria with Prussian Blue and Wicker White.

Finish:
1. Apply matte acrylic sealer.❀

Roses & Ribbon Box

Pictured on page 43

GATHER THESE SUPPLIES

Painting Surface:
Papîer maché box with half-round lid, 12" x 6" x 6"

Paints, Stains & Finishes:
Acrylic craft paints:
 Alizarin Crimson
 Green Forest
 Inca Gold
 Prussian Blue
 Wicker White
Matte acrylic sealer
Spray paint: Licorice

Brushes:
Flat, ¾", #12
Liner, #2
Scruffy brush

Other Supplies:
Tracing tool
Transfer tool

INSTRUCTIONS

Prepare:
1. Refer to General Instructions on pages 11–19. Spray box base and lid with Licorice. Let dry.

2. Using tracing and transfer tools, transfer Roses & Ribbon Box Pattern on page 45 onto box lid and base. Be certain the two pattern parts are aligned when lid is on box.

Paint the Design:
Fully Bloomed Rose:
1. Refer to Rose Worksheet on page 48. Using ¾" flat brush, paint rose with Alizarin Crimson and Wicker White.

Rosebuds:
1. Refer to Rosebuds & Ribbon Worksheet on page 47. Using #12 flat brush, paint rosebuds with Alizarin Crimson and Wicker White.

Leaves:
1. Refer to Leaf & Vine Worksheet on page 30. Paint leaves with Green Forest and Wicker White.

Curlicues & Name:
1. Using #2 liner, paint curlicues and name with inky Green Forest.

Ribbon:
1. Refer to Ribbon & Lace Worksheet on page 33. Using ¾" flat brush, paint ribbon with Prussian Blue and Wicker White.

Wisteria:
1. Refer to Scruffy Brush Worksheet on page 18. Using scruffy brush, pounce wisteria with Prussian Blue and Wicker White.

Gold Accents:
1. Using #2 liner, paint lines ¼" above bottom of box base and lid with inky Inca Gold. Let dry.

Finish:
1. Apply matte acrylic sealer.❋

Roses & Ribbon Box Pattern

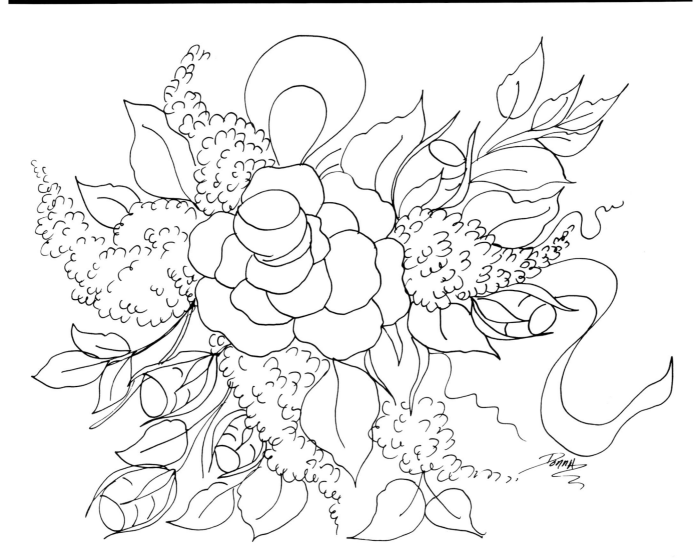

Enlarge pattern 180%

Rose Vase Pattern

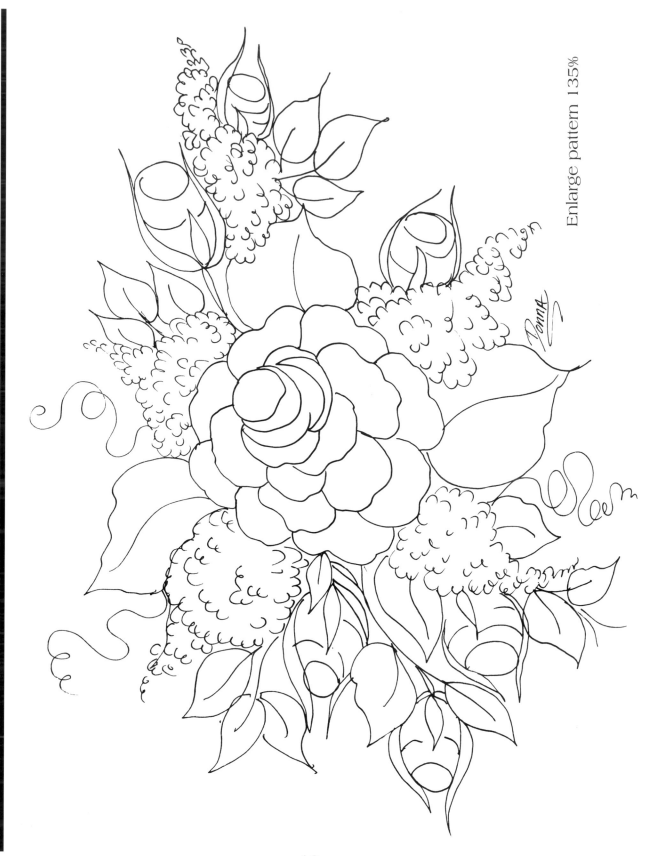

Enlarge pattern 135%

Rosebuds & Ribbon Worksheet

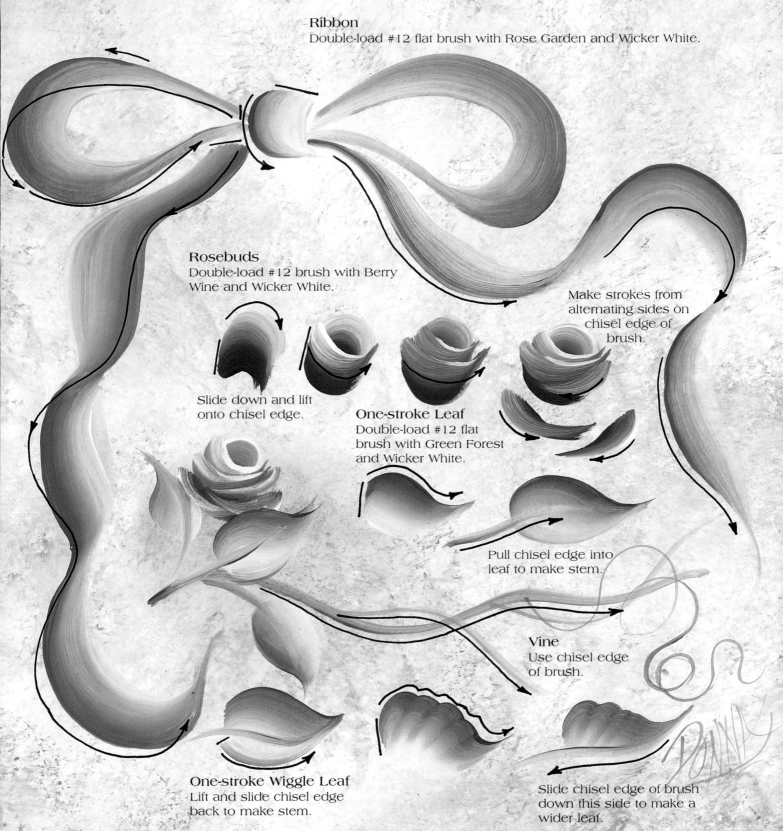

Ribbon
Double-load #12 flat brush with Rose Garden and Wicker White.

Rosebuds
Double-load #12 brush with Berry Wine and Wicker White.

Make strokes from alternating sides on chisel edge of brush.

Slide down and lift onto chisel edge.

One-stroke Leaf
Double-load #12 flat brush with Green Forest and Wicker White.

Pull chisel edge into leaf to make stem.

Vine
Use chisel edge of brush.

One-stroke Wiggle Leaf
Lift and slide chisel edge back to make stem.

Slide chisel edge of brush down this side to make a wider leaf.

Rose Worksheet

Double-load brush with Berry Wine and Wicker White.
Start on chisel edge of brush. Press firmly. Wiggle, making "m" motions. Watch white edge of brush. The shape should be like a shell. Also watch the Berry Wine edge of brush, which should be pivoting.

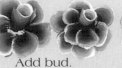
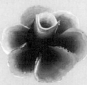
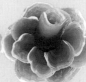
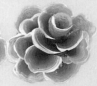

#2 flat brush.

Add bud.

Outer skirt of cabbage rose.

Paint bud in direction for rose to face.

#6 flat brush.

#12 flat brush.

¾" flat brush.

Chisel-edge filler petals.

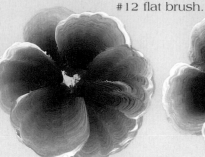
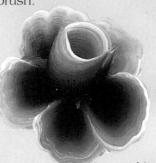
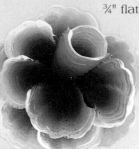
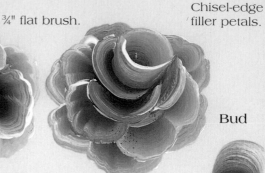

Outer skirt layering.

Inner skirt layer.
You can put wet paint over wet paint because no water is used.

Bud

¾" flat brush.

Petals overlap petals. Don't worry about center being covered. You will layer over it.

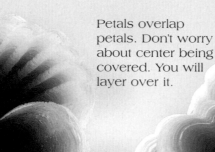

Depth is enhanced when brush is properly loaded.

Berry Wine shading to Wicker White.

2–4 strokes for filler petals.

Wrong: A hole is left in middle when first stroke is not pressed hard enough.

Wrong: Do not turn white edge from side to side.

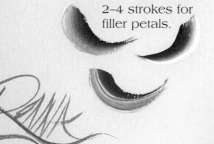

48

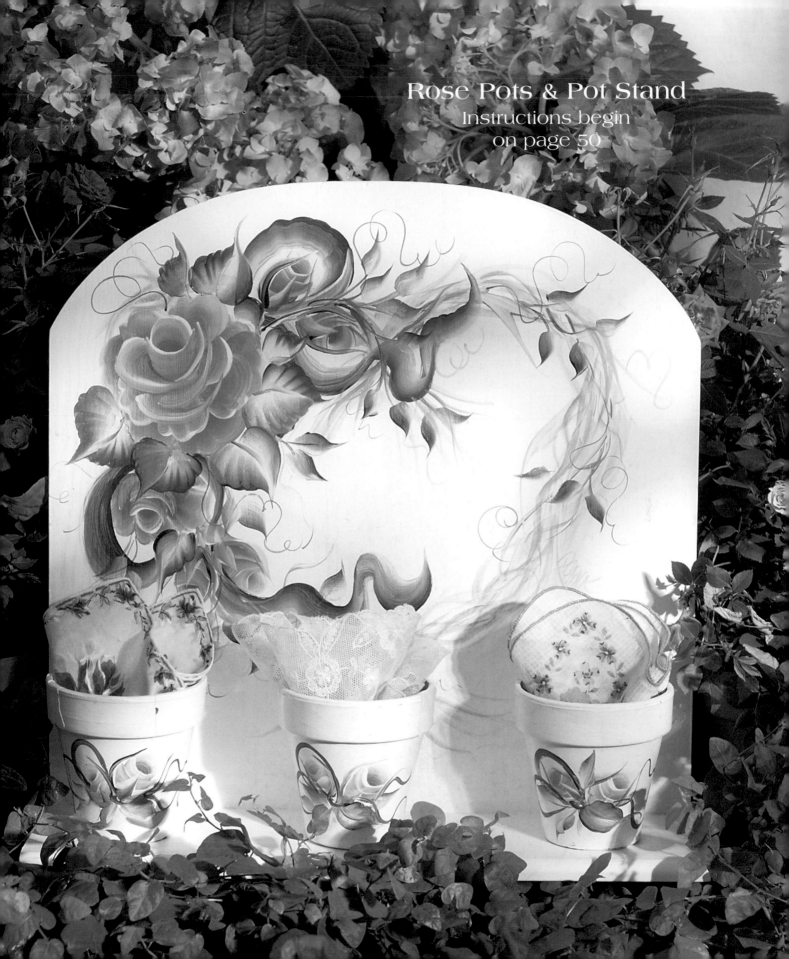

Rose Pots & Pot Stand
Instructions begin
on page 50

Rose Pots & Pot Stand

Pictured on page 49

GATHER THESE SUPPLIES

Painting Surface:
Wooden pot stand,
 14¼" x 14¼" x 4"
Clay pots, 3½" (3)

Paints, Stains & Finishes:
Acrylic craft paints:
 Country Twill
 Green Forest
 Night Sky
 Rose Chiffon
 Wicker White
Matte acrylic sealer

Brushes:
Flat, ¾", #12
Liner, #2

Other Supplies:
Sandpaper, 220 grit
Tack cloth
Tracing tool
Transfer tool

Rose Pots Pattern

Enlarge patterns 235%

Rose Pot Stand Pattern

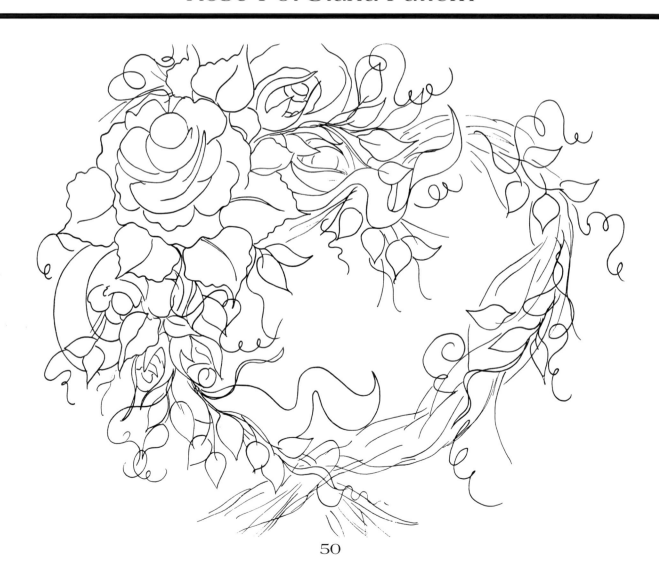

50

INSTRUCTIONS

Prepare:
1. Refer to General Instructions on pages 11–19. Using sandpaper, sand wood. Using a tack cloth, wipe away dust.

2. Using #12 flat brush, basecoat pots and pot stand with two coats of Wicker White. Let dry after each coat.

3. Using tracing and transfer tools, transfer Rose Pots Pattern on page 50 onto pots. Transfer Rose Pot Stand Pattern on page 50 onto pot stand.

Paint the Design:
Vine Wreath:
1. Refer to Painting a Chiseledged Vine on page 28. Using #12 flat brush, paint vines with Country Twill.

Roses and Rosebuds:
1. Refer to Rose Worksheet on page 48. Using #12 flat brush, paint roses and rosebuds with Rose Chiffon and Wicker White.

Ribbon:
1. Refer to Rosebuds & Ribbon Worksheet on page 47. Using ¾" flat brush, paint ribbon with Night Sky and Wicker White.

Leaves:
1. Refer to Painting an All-in-One Leaf on page 23. Using #12 flat brush, paint leaves with Green Forest and Wicker White.

Curlicues & Name:
1. Using #2 liner, paint curlicues and name with inky Green Forest.

Finish:
1. Apply matte acrylic sealer.✻

Rosebud Child's Chair

Pictured on page 52

GATHER THESE SUPPLIES

Painting Surface:
Wooden child's chair

Paints, Stains & Finishes:
Acrylic craft paints:
 Berry Wine
 Hunter Green
 Night Sky
 Rose Garden
 Wicker White
Matte acrylic sealer
White latex paint, satin finish
White primer

Brushes:
Flat, #12
Liner, #2

Other Supplies:
Sandpaper, 220 grit
Tack cloth
Tracing tool
Transfer tool

INSTRUCTIONS

Prepare:
1. Refer to General Instructions on pages 11–19. Using sandpaper, sand chair. Using tack cloth, wipe away dust.

2. Using #12 flat brush, apply white primer, following manufacturer's instructions. Let dry.

3. Base-coat with two coats white latex paint. Let dry between coats.

4. Using tracing and transfer tools, transfer Rosebud Child's Chair Seat and Back Patterns on page 53 onto chair. Revise pattern to fit size of chair by curving some vines upward. Freehand the general shape of vines to fit.

Paint the Design:
1. *Option:* Use the One Stroke™ technique and a #12 flat brush to write a child's name on the chair. Using #12 flat brush, make one stroke for each section of the letter with Rose Garden and Wicker White.

2. Refer to Rosebuds & Ribbon Worksheet on page 47. Paint rosebuds with Berry Wine and Wicker White.

3. Paint bows with Rose Garden and Wicker White.

4. Using #12 flat brush, paint vine and leaves with Hunter Green and Wicker White.

5. Refer to Ribbon & Lace Worksheet on page 33. Paint filler flowers by making overlapping "U" strokes with Night Sky and Wicker White.

6. Using #2 liner, paint curlicues and name with inky Hunter Green. Let dry.

Finish:
1. Apply matte acrylic sealer.✻

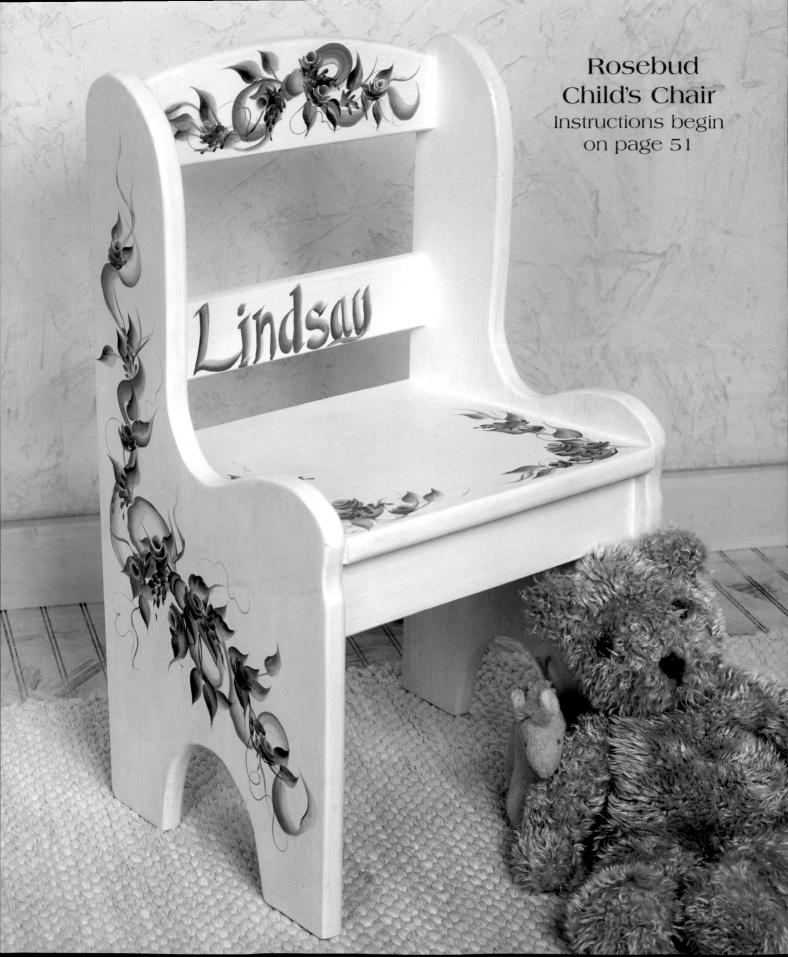

Rosebud
Child's Chair
Instructions begin
on page 51

Rosebud Child's Chair Seat Pattern

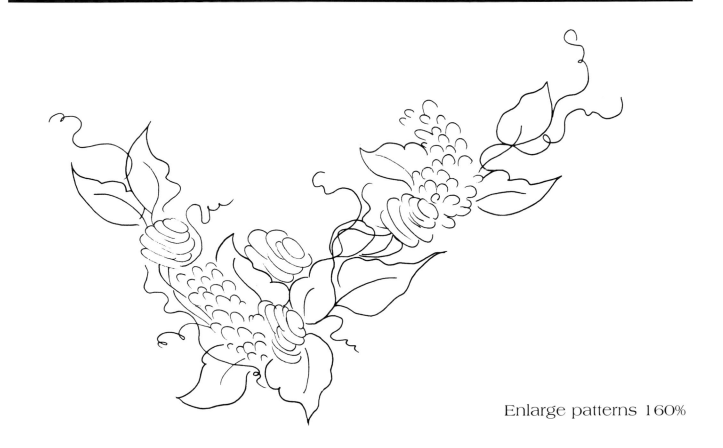

Enlarge patterns 160%

Rosebud Child's Chair Back Pattern

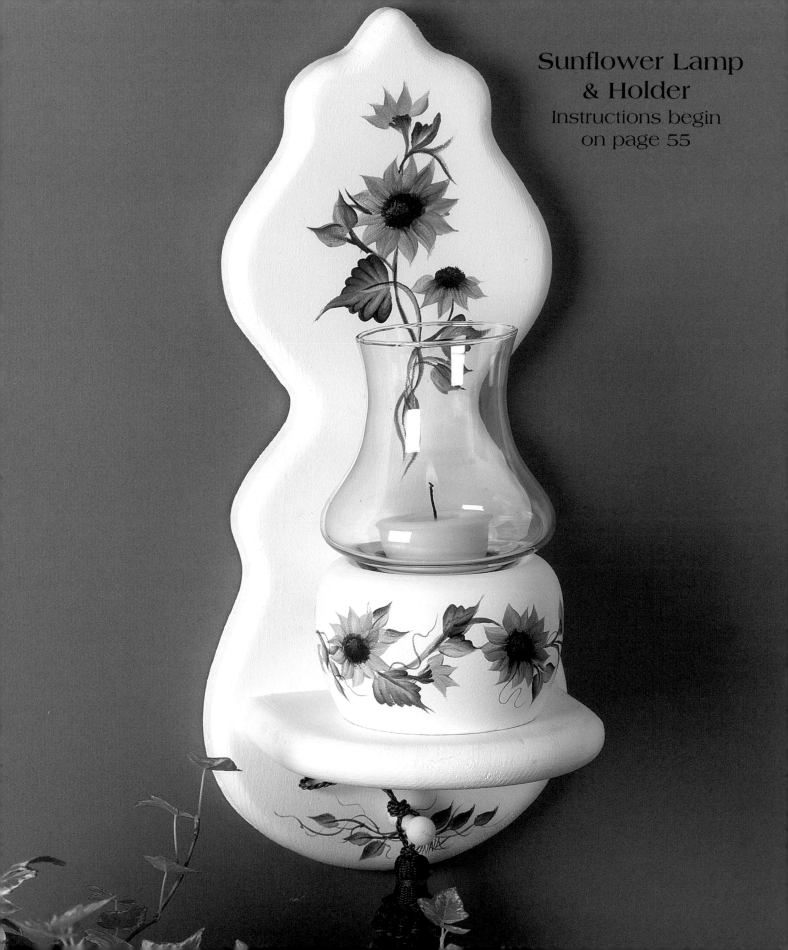

Sunflower Lamp
& Holder
Instructions begin
on page 55

Sunflower Lamp & Holder

Pictured on page 54

GATHER THESE SUPPLIES

Painting Surface:
Wooden lamp holder with glass chimney and peg, 14¼" x 6¼" x 6¼"

Paints, Stains & Finishes:
Acrylic craft paints:
 Green Forest
 Licorice
 Maple Syrup
 School Bus Yellow
 Wicker White
 Yellow Ochre
Matte acrylic sealer

Brushes:
Flat, #2, #6
Liner, #1
Scruffy brush

Other Supplies:
Sandpaper, grit 220
Tack cloth
Tracing tool
Transfer tool

INSTRUCTIONS

Prepare:
1. Refer to General Instructions on pages 11–19. Using sandpaper, sand wooden lamp holder. Using tack cloth, wipe away dust.

2. Using #2 flat brush, basecoat lamp holder with Wicker White. Let dry.

3. Using tracing and transfer tools, transfer Sunflower Lamp Holder, Top, and Bottom Patterns onto upper and lower backboard and lamp holder.

Paint the Design:
Vines & Leaves:
1. Refer to Small Sunflower Worksheet on page 56. Using chisel edge of #6 flat brush, paint vines with Green Forest and School Bus Yellow.

Sunflowers:
1. Using scruffy brush, paint centers with Licorice and Maple Syrup.

2. Using either the #2 or #6 flat brush (depending on size of leaf) paint petals, with School Bus Yellow and Yellow Ochre. Pull from center outward for each petal.

Curlicues & Name:
1. Using #1 liner, paint curlicues and sign your name with inky Green Forest.

Finish:
1. Apply matte acrylic sealer.�֍

Sunflower Lamp Top Pattern

Sunflower Lamp Bottom Pattern

Enlarge patterns 180%

Sunflower Lamp Holder Pattern

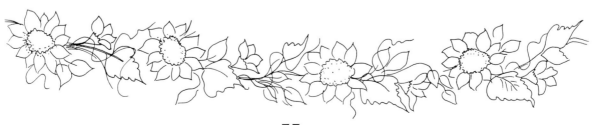

Small Sunflower Worksheet

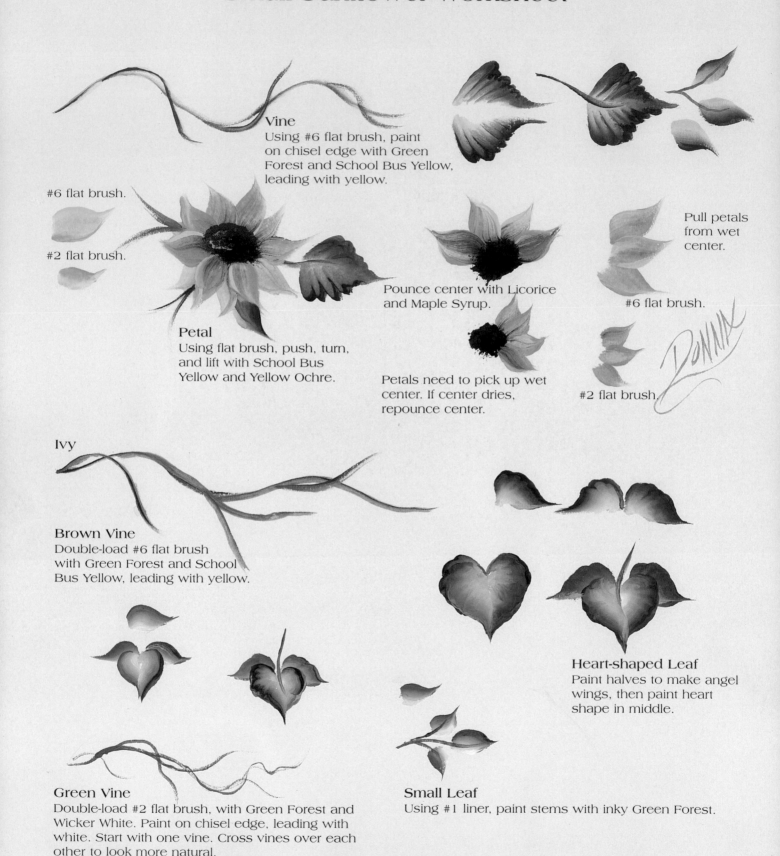

Vine
Using #6 flat brush, paint on chisel edge with Green Forest and School Bus Yellow, leading with yellow.

#6 flat brush.

#2 flat brush.

Petal
Using flat brush, push, turn, and lift with School Bus Yellow and Yellow Ochre.

Pounce center with Licorice and Maple Syrup.

Petals need to pick up wet center. If center dries, repounce center.

Pull petals from wet center.

#6 flat brush.

#2 flat brush.

Ivy

Brown Vine
Double-load #6 flat brush with Green Forest and School Bus Yellow, leading with yellow.

Green Vine
Double-load #2 flat brush, with Green Forest and Wicker White. Paint on chisel edge, leading with white. Start with one vine. Cross vines over each other to look more natural.

Small Leaf
Using #1 liner, paint stems with inky Green Forest.

Heart-shaped Leaf
Paint halves to make angel wings, then paint heart shape in middle.

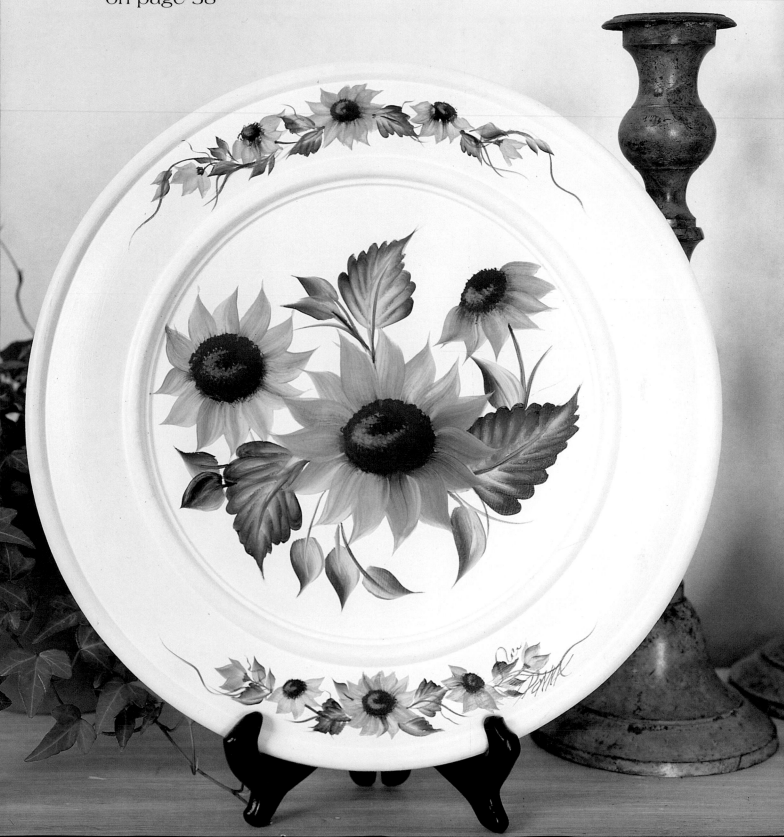

Sunflower Plate
Instructions begin
on page 58

Instructions begin on page 58

Sunflower Plate

Pictured on page 57

GATHER THESE SUPPLIES

Painting Surface:
Wooden plate with beaded rim, 14" dia.

Paints, Stains & Finishes:
Acrylic craft paints:
 Green Forest
 Licorice
 Maple Syrup
 School Bus Yellow
 Wicker White
 Yellow Ochre
Matte acrylic sealer

Brushes:
Flat, ¾", #2, #6, #12
Liner, #2
Scruffy brush

Other Supplies:
Sandpaper, 220 grit

Tack cloth
Tracing tool
Transfer tool

INSTRUCTIONS

Prepare:
1. Refer to General Instructions on pages 11–19. Using sandpaper, sand plate. Using tack cloth, wipe away dust.

2. Using #12 flat brush, basecoat plate with Wicker White. Let dry.

3. Using tracing and transfer tools, transfer Sunflower Plate Rim Pattern below and Sunflower Plate Center Pattern on page 59 onto plate.

Paint the Design:
Leaves:
1. Refer to Painting an All-in-One Leaf on page 23. Using either the #2 or #6 flat brush (depending on size of leaf) paint leaves with Green Forest and Wicker White.

2. Refer to Sunflower Worksheet on page 60. Using ¾" flat brush, paint sunflower leaves with Green Forest and School Bus Yellow.

Sunflowers:
1. Using #12 flat brush, paint sunflowers with School Bus Yellow and Yellow Ochre.

2. Using scruffy brush, pounce sunflower centers with Licorice and Maple Syrup.

3. Pounce centers with Yellow Ochre to highlight.

Tendrils:
1. Using #2 liner, paint tendrils with Green Forest.

Finish:
1. Apply matte acrylic sealer.✳

Sunflower Plate Rim Pattern

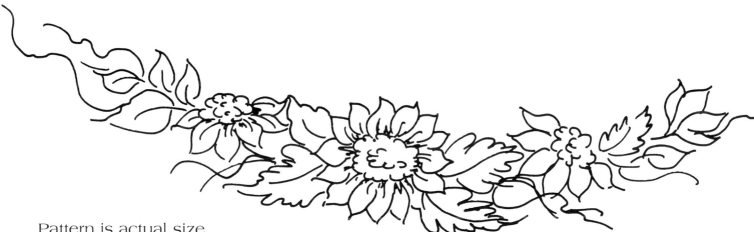

Pattern is actual size

Sunflower Plate Center Pattern

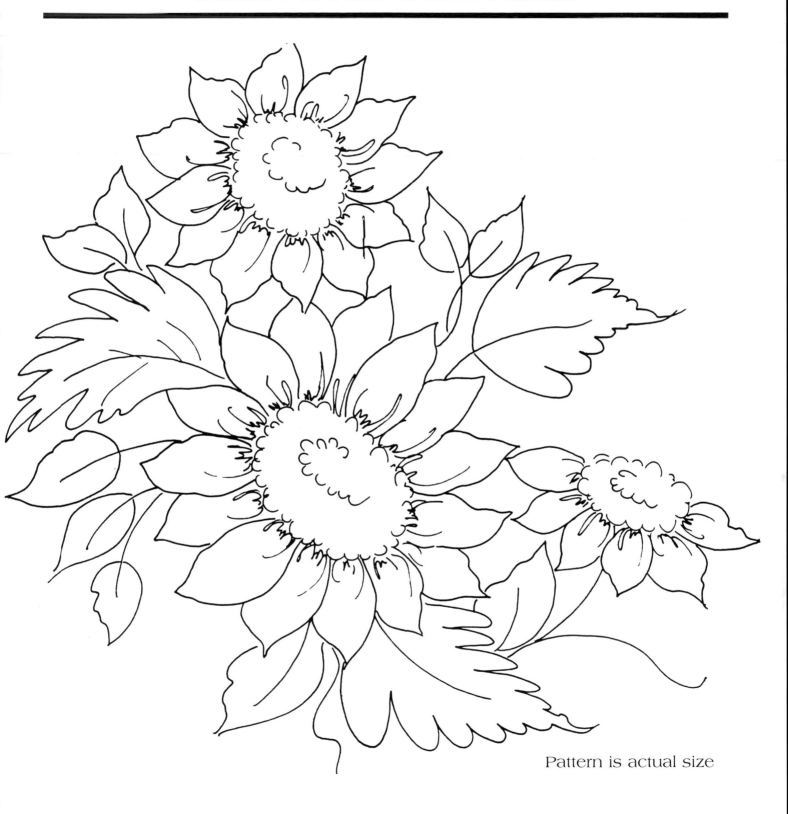

Pattern is actual size

Sunflower Worksheet

Sunflower Center
Using scruffy brush, pounce center with Maple Syrup and Licorice.

Petal
Using #12 flat brush, make push-turn-lift stroke with School Bus Yellow and Yellow Ochre.

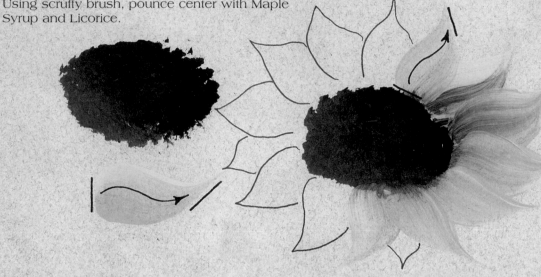

When petals are dry, add details with a black, fine-tip permanent marker.

Paint petals while centers are still wet, pulling out from the center of each petal. This will add some shading to center of petals.

Leaf
Multiload ¾" flat brush with Green Forest, Leaf Green, and School Bus Yellow.

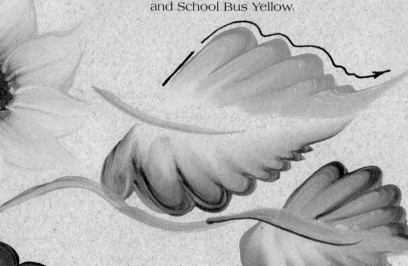

C-stroke Flower
Using #12 flat brush, paint five C-strokes for each flower with Midnight and Wicker White. Using handle end of brush, dot center with School Bus Yellow.

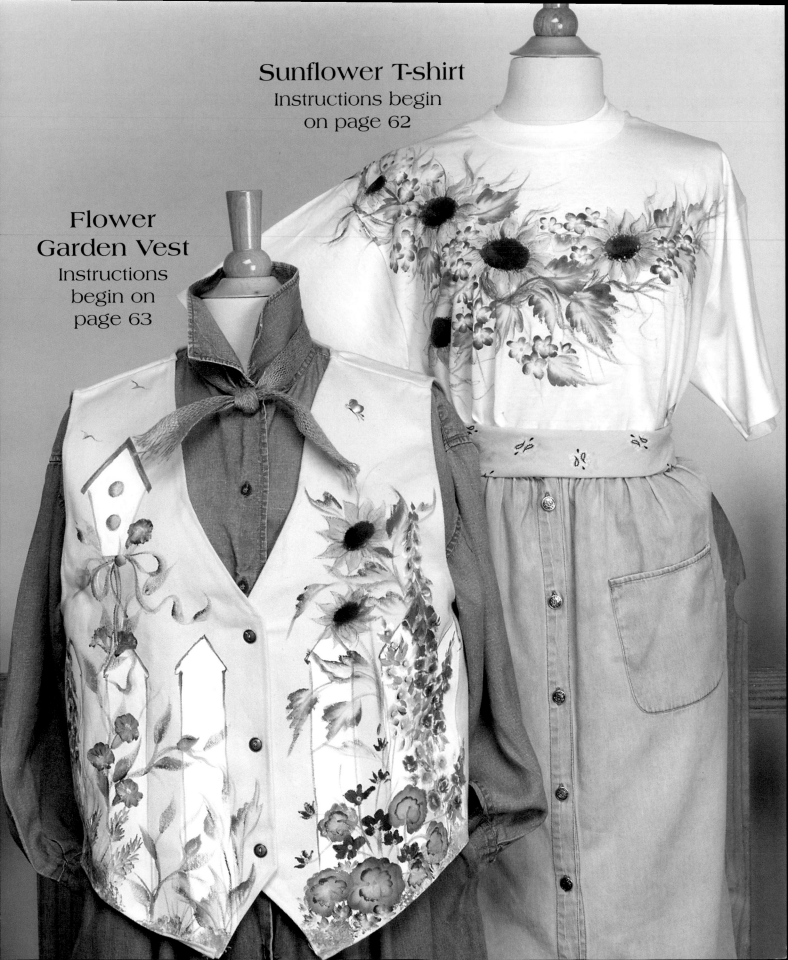

Sunflower T-shirt
Instructions begin
on page 62

**Flower
Garden Vest**
Instructions
begin on
page 63

Sunflower
T-shirt

Pictured on page 61

GATHER THESE SUPPLIES

Painting Surface:
White T-shirt

Paints, Stains & Finishes:
Acrylic craft paints:
 Dark Brown
 Green Forest
 Leaf Green
 Licorice
 Midnight
 School Bus Yellow
 Wicker White
Textile medium

Brushes:
Flat, ¾", #12
Scruffy brush

Other Supplies:
Fine-tip permanent marker,
 black
Iron
Tracing tool
Transfer tool

INSTRUCTIONS

Prepare:
1. Refer to General Instructions on pages 11–19. Prepare T-shirt by washing and drying, following manufacturer's instructions. Do not use fabric softener. Iron garment until smooth.

2. Using tracing and transfer tools, transfer Sunflower T-shirt Pattern onto shirt.

3. Mix one part textile medium with two parts of each acrylic paint on a paint palette.

Paint the Design:
Sunflowers:
1. Refer to Sunflower Worksheet on page 60. Using #12 flat brush, paint sunflowers with School Bus Yellow.

2. Using scruffy brush, pounce center of sunflowers with Dark Brown and Licorice.

Leaves:
1. Using ¾" flat brush, paint leaves with Green Forest, Leaf Green, and School Bus Yellow.

C-stroke Flowers:
1. Using #12 flat brush, paint C-stroke flowers with Midnight and Wicker White.

2. Using handle end of brush, dot centers of flowers with School Bus Yellow.

Vines:
1. Using chisel edge of brush, paint vines with Dark Brown. Let dry.

Finish:
1. Use black, fine-tip marker to outline sunflower petals and to add detailing.

2. Let dry 24 hours. Heat-set with iron.✳

Sunflower T-shirt Pattern

Enlarge pattern 350%

62

Flower Garden Vest

Pictured on page 61

GATHER THESE SUPPLIES

Painting Surface:
Natural canvas vest

Paints, Stains & Finishes:
Acrylic craft paints:
 Berry Wine
 Dark Brown
 Green Forest
 Leaf Green
 Licorice
 Midnight
 Napthol Crimson
 School Bus Yellow
 Sterling Blue
 Violet Pansy
 Wicker White
 Yellow Ochre
Textile medium

Brushes:
Flat, ¾", #12
Liner, #2
Scruffy brush

Other Supplies:
Fine-tip permanent marker,
 black
Iron
Tracing tool
Transfer tool

INSTRUCTIONS

Prepare:
1. Refer to General Instructions on pages 11–19. Prepare natural canvas vest by washing and drying, following manufacturer's instructions. Do not use fabric softener. Iron garment so it is smooth.

2. Using tracing and transfer tools, transfer fence pickets and birdhouse from Flower Garden Vest Left and Right Side Patterns on pages 64 and 65 onto vest.

3. Mix one part textile medium with two parts of each acrylic color on a paint palette.

Paint the Design:
Fence & Birdhouse:
1. Using #12 flat brush, base-coat fence pickets and birdhouse walls with Wicker White.

2. Outline pickets and birdhouse walls and paint birdhouse pole and holes with Dark Brown.

3. Paint birdhouse roof with Green Forest, Leaf Green, and Wicker White.

4. Refer to Ribbon and Lace Worksheet on page 33. Paint bow on birdhouse pole with Midnight and Wicker White. Let dry.

Sunflowers:
1. Using tracing and transfer tools, transfer sunflowers from Flower Garden Vest Left Side Pattern on page 64.

2. Refer to Sunflower Worksheet on page 60. Paint sunflowers with School Bus Yellow.

3. When petals are dry, add details with black, fine-tip permanent marker.

Leaves:
1. Refer to Sunflower Worksheet on page 60. Using ¾" flat brush, paint leaves with Green Forest, Leaf Green, and School Bus Yellow.

Greenery:
1. Refer to Scruffy Brush Worksheet on page 18. Using scruffy brush, pounce greenery along bottom of vest with Green Forest and Yellow Ochre. Pounce greenery along bottom of vest.

Flowers:
1. Using tracing and transfer tools, transfer flower from Flower Garden Vest Left and Right Side Patterns on pages 64 and 65.

2. Refer to Flower Garden Worksheet on page 66. Using #12 flat brush, paint foxglove with Berry Wine and Wicker White.

3. Paint morning glories with Violet Pansy and Wicker White.

4. Paint hollyhocks with Sterling Blue and Wicker White.

5. Paint C-strokes for geraniums with Berry Wine and Napthol Crimson.

6. Paint all leaves and stems following Flower Garden Worksheet on page 66.

C-stroke Flowers:
1. Paint C-stroke flowers at bottom of vest around geraniums with Midnight and Wicker White.

2. Using handle end of brush, dot centers with School Bus Yellow and Wicker White.

Blue Flowers:
1. Using chisel edge of #12 flat brush, paint blue flowers below morning glories with Midnight and Wicker White.

Birds:
1. Using #12 flat brush, stroke in chisel edge birds above birdhouse with Midnight.

Butterfly:
1. Paint upper butterfly wings, using two C-strokes with Violet Pansy and Wicker White.

2. Using chisel edge of brush, paint bottom wings.

3. Using #2 liner, paint butterfly body and antennae with Licorice.

Finish:
1. Let dry 24 hours. Heat–set with iron.✻

Flower Garden Vest
Left Side Pattern

Enlarge pattern 200%

Flower Garden Vest Right Side Pattern

Enlarge pattern 200%

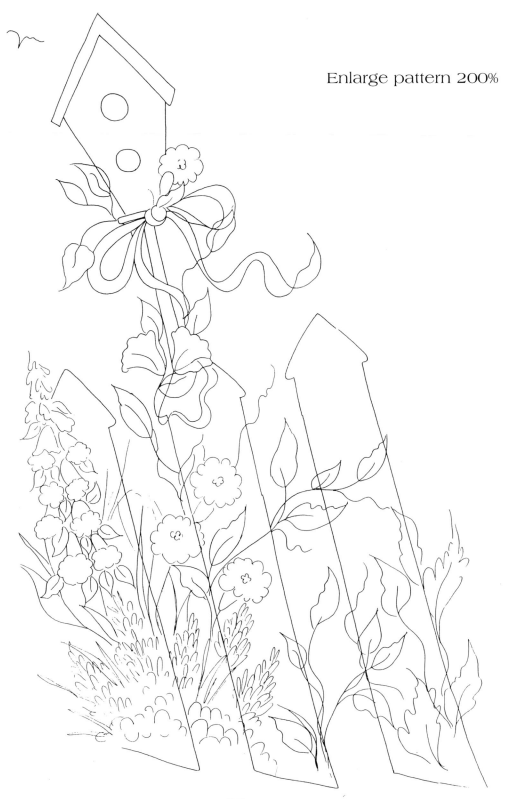

Flower Garden Worksheet

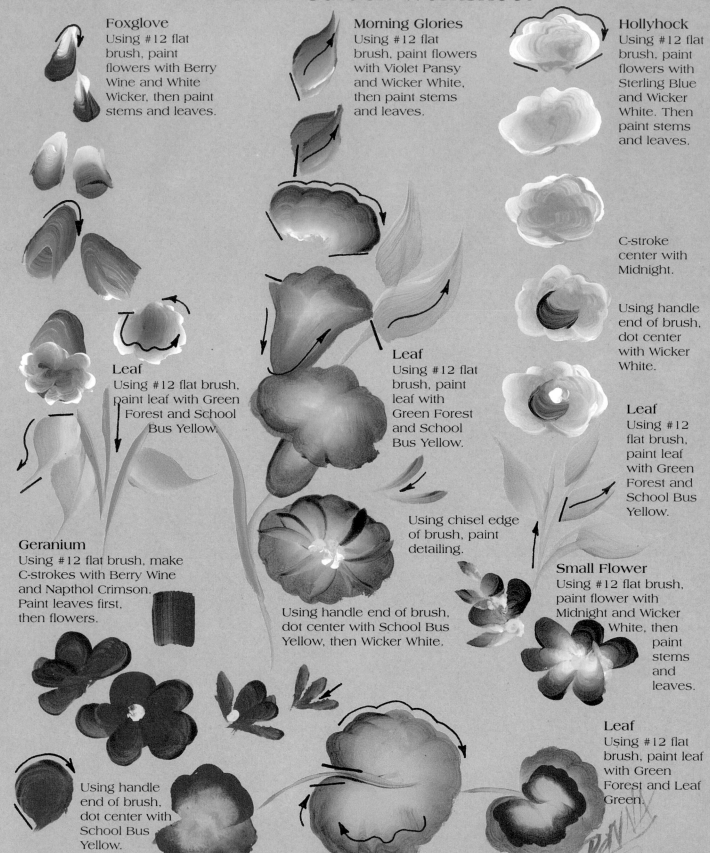

Foxglove
Using #12 flat brush, paint flowers with Berry Wine and White Wicker, then paint stems and leaves.

Morning Glories
Using #12 flat brush, paint flowers with Violet Pansy and Wicker White, then paint stems and leaves.

Hollyhock
Using #12 flat brush, paint flowers with Sterling Blue and Wicker White. Then paint stems and leaves.

C-stroke center with Midnight.

Using handle end of brush, dot center with Wicker White.

Leaf
Using #12 flat brush, paint leaf with Green Forest and School Bus Yellow.

Leaf
Using #12 flat brush, paint leaf with Green Forest and School Bus Yellow.

Leaf
Using #12 flat brush, paint leaf with Green Forest and School Bus Yellow.

Using chisel edge of brush, paint detailing.

Geranium
Using #12 flat brush, make C-strokes with Berry Wine and Napthol Crimson. Paint leaves first, then flowers.

Using handle end of brush, dot center with School Bus Yellow, then Wicker White.

Small Flower
Using #12 flat brush, paint flower with Midnight and Wicker White, then paint stems and leaves.

Leaf
Using #12 flat brush, paint leaf with Green Forest and Leaf Green.

Using handle end of brush, dot center with School Bus Yellow.

66

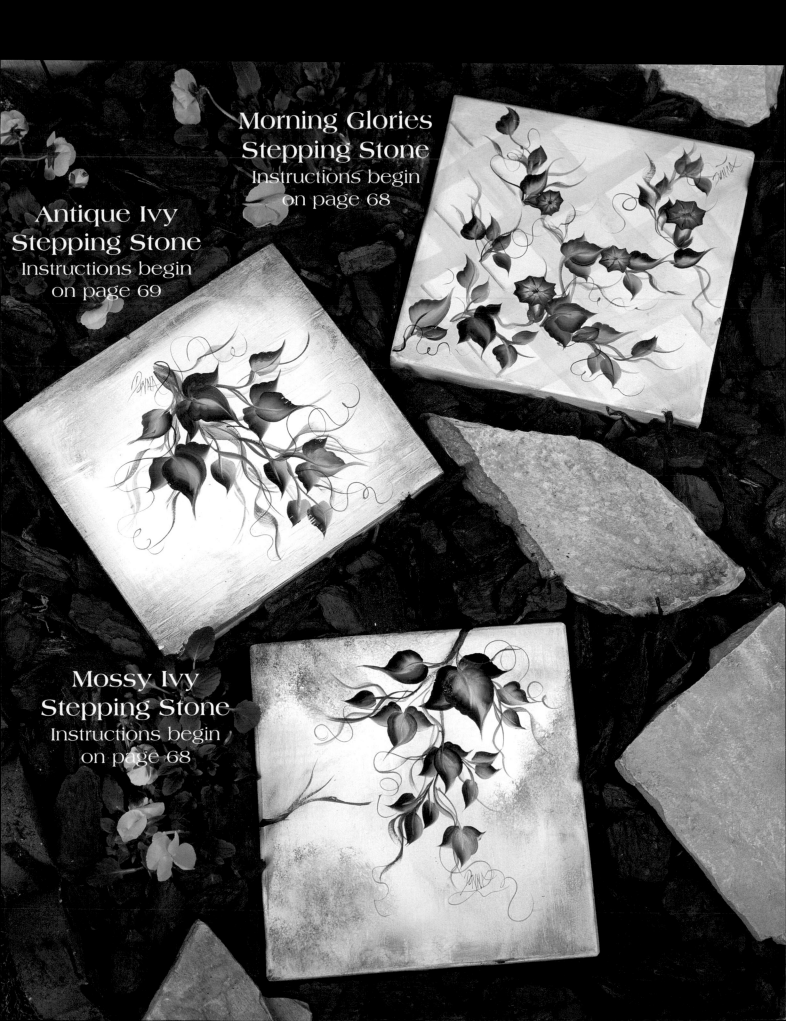

Morning Glories
Stepping Stone
Instructions begin
on page 68

Antique Ivy
Stepping Stone
Instructions begin
on page 69

Mossy Ivy
Stepping Stone
Instructions begin
on page 68

Morning Glories Stepping Stone

Pictured on page 67

GATHER THESE SUPPLIES

Painting Surface:
Pressure-treated wood or
 smooth concrete stepping
 stones, 12" x 12" x 2"

Paints, Stains & Finishes:
Acrylic craft paints:
 Green Forest
 Maple Syrup
 School Bus Yellow
 Sunflower
 Violet Pansy
 Wicker White
Outdoor varnish or
 polyurethane
White primer

Brushes:
Flat, ¾", #12
Liner, #2
Sponge brush

Other Supplies:
Sandpaper, 220 grit
Tack cloth
Tracing tool
Transfer tool

INSTRUCTIONS

Prepare:
1. Refer to General Instructions
on pages 11–19. Using sand-
paper, sand wood. Using tack
cloth, wipe away dust.

2. Using #12 flat brush, apply
white primer, following
manufacturer's instructions.
Let dry.

3. Base-coat with Wicker
White. Let dry.

4. Using ¾" flat brush, paint
lattice with inky Sunflower.

5. Using #12 flat brush, shade
one edge of lattice with Maple
Syrup. Refer to photo on page
67 as a guide. Let dry.

6. Using tracing and transfer
tools, transfer Morning Glories
Stepping Stone Pattern on
page 70 onto stepping stone.

Paint the Design:
Vines:
1. Refer to Leaf & Vine Work-
sheet on page 30. Using #12
flat brush, paint vines with
Green Forest and Wicker
White, creating the structure
for the design.

Leaves:
1. Paint one-stroke leaves
with Green Forest and Wicker
White.

2. Paint two-stroke leaves with
Green Forest and Wicker
White.

Flowers:
1. Refer to Flower Garden
Worksheet on page 66.

2. Using #12 flat brush, paint
morning glories with Violet
Pansy and Wicker White.

3. Using handle end of brush,
dot center with School Bus
Yellow, then Wicker White. Dot
very center with Green Forest.

4. Using chisel edge of brush,
paint detail lines with Violet
Pansy.

Curlicues & Name:
1. Using #2 liner, paint curli-
cues and sign your name with
inky Green Forest.

Finish:
1. Using sponge brush,
apply outdoor varnish or
polyurethane.✻

Mossy Ivy Stepping Stone

Pictured on page 67

GATHER THESE SUPPLIES

Painting Surface:
Pressure-treated wood or
 smooth concrete stepping
 stone 12" x 12" x 2"

Paints, Stains & Finishes:
Acrylic craft paints:
 Green Forest
 Maple Syrup
 Wicker White
Outdoor varnish or
 polyurethane
White primer

Brushes:
Flat, ¾", #12
Liner, #2
Scruffy brush
Sponge brush

Other Supplies:
Sandpaper, 220 grit
Tack cloth
Tracing tool
Transfer tool

INSTRUCTIONS

Prepare:
1. Refer to General Instructions on pages 11–19. Using sandpaper, sand wood. Using tack cloth, wipe away dust.

2. Using #12 flat brush, apply white primer, following manufacturer's instructions. Let dry.

3. Base coat with Wicker White. Let dry.

4. Refer to Scruffy Brush Worksheet on page 18. Using scruffy brush, pounce mossy background around edges of stepping stone with Green Forest, Maple Syrup, and Wicker White. Refer to photo on page 67 as a guide. Let dry.

5. Using tracing and transfer tools, transfer Mossy Ivy Stepping Stone Pattern on page 71 onto stepping stone.

Paint the Design:
Vines:
1. Refer to Leaf & Vine Worksheet on page 30. Using ¾" flat brush, paint vines with Maple Syrup and Wicker White.

Leaves:
1. Paint ivy leaves with Green Forest and Wicker White.

Curlicues & Name:
1. Using #2 liner, paint curlicues and sign your name with inky Green Forest.

Finish:
1. Using sponge brush, apply outdoor varnish or polyurethane.✳

Antique Ivy Stepping Stone

Pictured on page 67

GATHER THESE SUPPLIES

Painting Surface:
Pressure treated wood or smooth concrete stepping stone 12" x 12" x 2"

Paints, Stains & Finishes:
Acrylic craft paints:
 Green Forest
 Maple Syrup
 Wicker White
White primer
Outdoor varnish or polyurethane

Brushes:
Flat, ¾", #12
Liner, #2
Sponge brush

Other Supplies:
Sandpaper, 220 grit
Tack cloth
Tracing tool
Transfer tool

INSTRUCTIONS

Prepare:
1. Refer to General Instructions on pages 11–19. Using sandpaper, sand wood. Using tack cloth, wipe away dust.

2. Using #12 flat brush, apply white primer, following manufacturer's instructions. Let dry.

3. Base-coat with Wicker White. Let dry.

4. Using ¾" flat brush, paint antiqued background around edges of stepping stone with Maple Syrup. Refer to photo on page 67 as a guide. Let dry.

5. Using tracing and transfer tools, transfer Antique Ivy Stepping Stone Pattern on page 72 onto stepping stone.

Paint the Design:
Vines:
1. Refer to Leaf & Vine Worksheet on page 30. Using ¾" flat brush, paint vines with Maple Syrup and Wicker White.

Leaves:
1. Paint ivy leaves with Green Forest and Wicker White.

Curlicues and Name:
1. Using #2 liner, paint curlicues and sign your name with inky Green Forest.

Finish:
1. Using sponge brush, apply outdoor varnish or polyurethane.✳

Morning Glories Stepping Stone Pattern

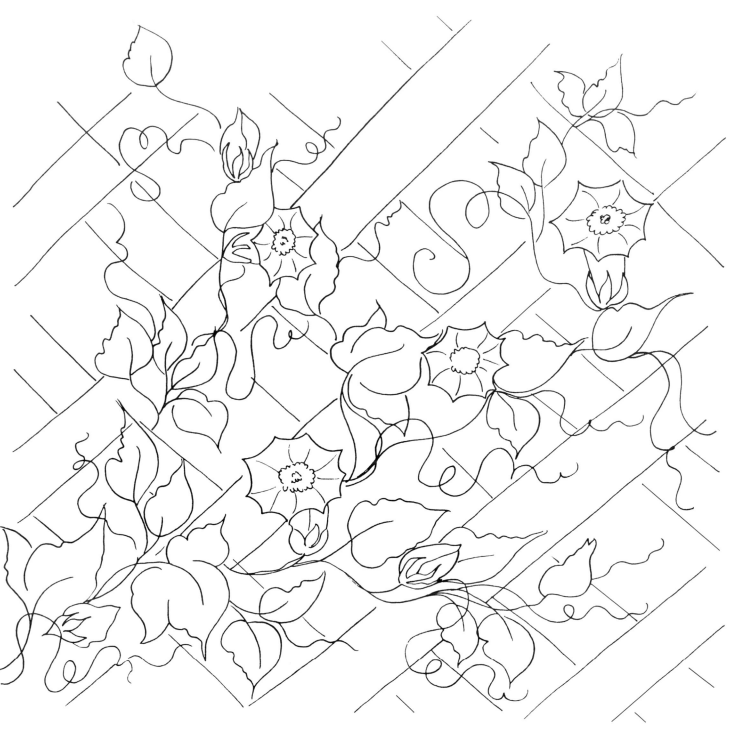

Enlarge pattern 155%

Mossy Ivy Stepping Stone Pattern

Enlarge pattern 155%

Antique Ivy Stepping Stone Pattern

Enlarge pattern 155%

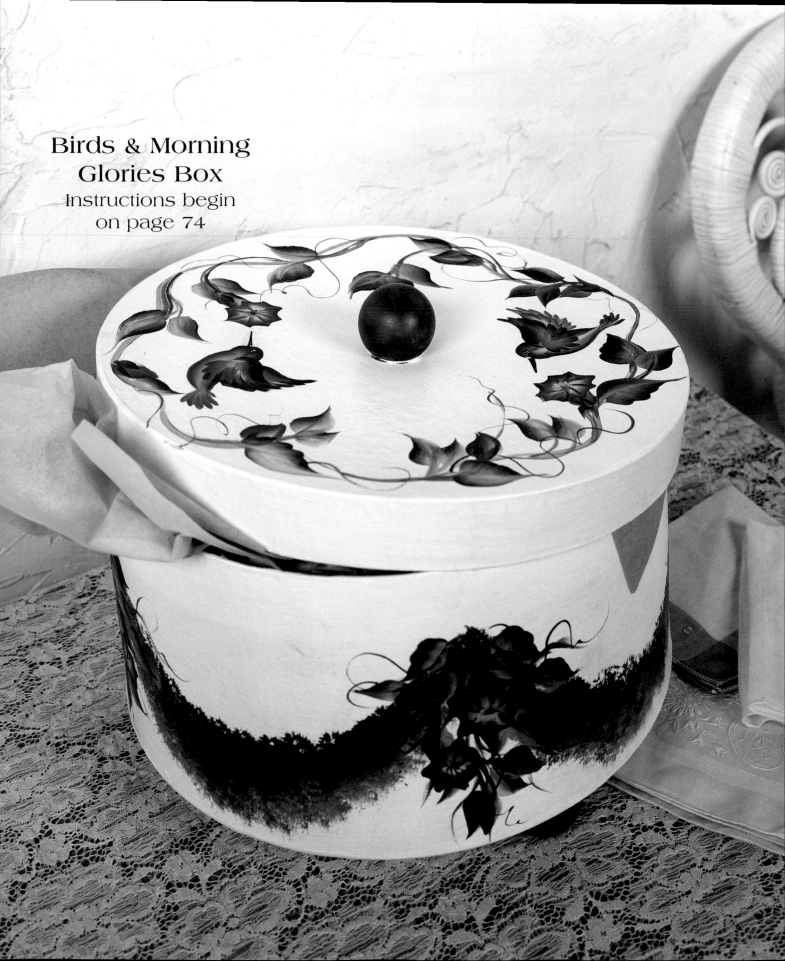

Birds & Morning Glories Box
Instructions begin
on page 74

Birds & Morning Glories Box

Pictured on page 73

GATHER THESE SUPPLIES

Painting Surface:
Round papîer maché box,
 12" dia.
Round wooden drawer pulls, (4)

Paints, Stains & Finishes:
Acrylic craft paints:
 Berry Wine
 Burnt Umber
 Green Forest
 School Bus Yellow
 Sunflower
 Violet Pansy
 Wicker White
Matte acrylic sealer

Brushes:
Flat, #12
Liner, #2
Scruffy brush

Other Supplies:
Sandpaper, 220 grit
Tack cloth
Thick white craft glue
Tracing tool
Transfer tool

INSTRUCTIONS

Prepare:
1. Refer to General Instructions on pages 11–19. Using sandpaper, sand draw pulls. Using tack cloth, wipe away dust.

2. Using #12 flat brush, base-coat box with Wicker White.

3. Base-coat drawer pulls with Green Forest. Let dry.

4. Refer to Scruffy Brush Worksheet on page 18. Using a scruffy brush, pounce greenery swags on box side with Green Forest and Wicker White. Refer to photo on page 73 as guide. Let dry.

5. Using tracing and transfer tools, transfer Birds & Morning Glories Box Lid and Side Patterns onto box.

Paint the Design:
Vines and Leaves:
1. Refer to Leaf & Vine Worksheet on page 30. Using #12 flat brush, paint vines with Green Forest and Wicker White.

2. Paint one- and two-stroke leaves with Green Forest and School Bus Yellow.

Morning Glories:
1. Refer to Flower Garden Worksheet on page 66. Paint morning glories with Violet Pansy and Wicker White.

2. Using handle end of brush, dot center with School Bus Yellow, then Wicker White. Dot very center with Green Forest.

3. Using chisel edge of brush, paint detail lines with Violet Pansy.

Curlicues & Name:
1. Using #2 liner, paint curlicues with inky Green Forest.

Hummingbirds:
1. Using chisel edge of #12 flat brush, paint upper body with Green Forest and Wicker White, starting at top of head and ending at point of tail.

2. Repeat same stroke as before with Berry Wine and Wicker White to form lower half of bird's body.

3. Using chisel edge of brush, paint back wing and tail feathers with Green Forest and Wicker White. Let dry.

Birds & Morning Glories Box Side Pattern

Enlarge pattern 220%

4. Paint front wing with Green Forest and Wicker White. Overlap onto back wing.

5. Using chisel edge of #12 flat brush, pull feathers into tail with Green Forest and Wicker White.

6. Using #2 liner, paint beak with Burnt Umber.

7. Using handle end of brush, dot eye with Burnt Umber. Apply a smaller dot of Wicker White on top.

Finish:

1. Adhere one drawer pull at center of lid with thick white craft glue. Adhere remaining drawer pulls to bottom of box for feet. Let dry.

2. Apply matte acrylic sealer.✱

Birds & Morning Glories Box
Lid Pattern

Enlarge pattern 220%

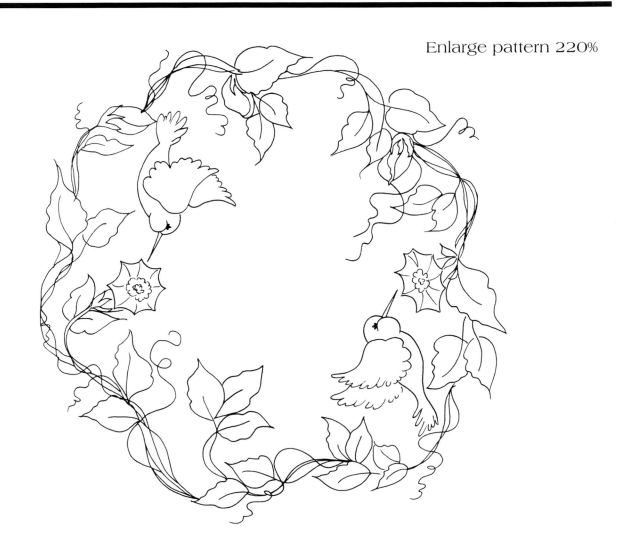

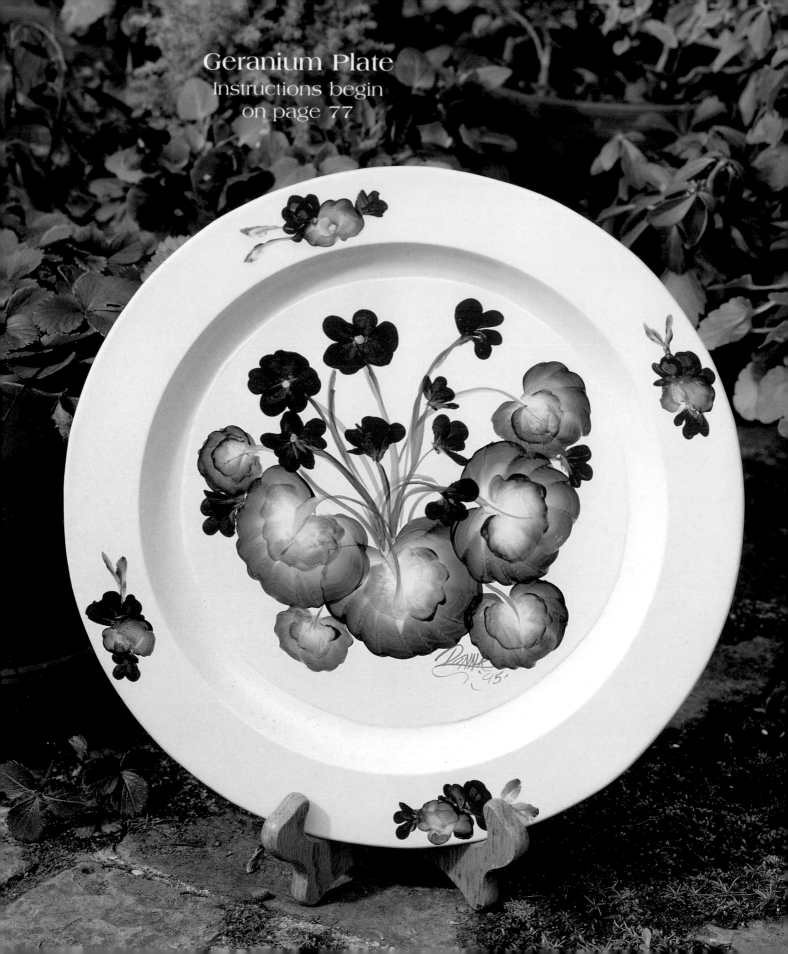

Geranium Plate
Instructions begin
on page 77

Geranium Plate

Pictured on page 78

GATHER THESE SUPPLIES

Painting Surface:
Tin plate, 12" dia.

Paints, Stains & Finishes:
Acrylic craft paints:
 Berry Wine
 Green Forest
 Napthol Crimson
 School Bus Yellow
 Wicker White
Spray paint: Wicker White
Matte acrylic sealer

Brushes:
Flat, #12

Other Supplies:
Clean cloth
Clean towel
Tracing tool
Transfer tool
Vinegar

INSTRUCTIONS

Prepare:
1. Refer to General Instructions on pages 11–19. Using a clean cloth dampened with vinegar and water, wipe oily residue off tin plate. Dry with clean towel.

2. Base-coat tin plate with Wicker White spray paint.

3. Using tracing and transfer tools, transfer Geranium Plate Pattern onto plate.

Paint the Design:
Geranium Flowers:
1. Refer to Geranium Work-sheet on page 78. Using #12 flat brush, paint flower petals with Berry Wine and Napthol Crimson.

2. Using handle end of brush, dot flower centers with School Bus Yellow.

Geranium Leaves:
1. Paint leaves Green Forest and Wicker White.

2. Paint shadow around inside of leaves with inky Napthol Crimson.

Stems:
1. Using chisel edge of brush, paint stems with Green Forest.

Finish:
1. Apply matte acrylic sealer.✳

Geranium Plate Pattern

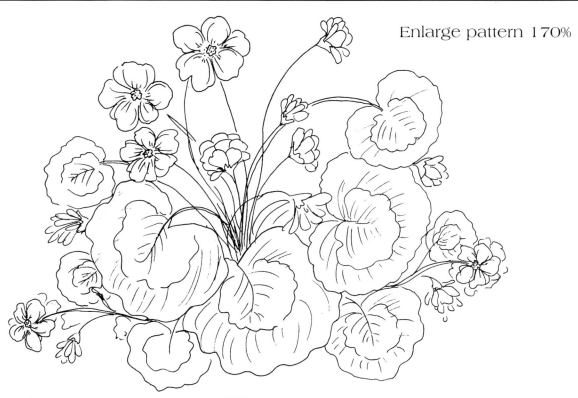

Enlarge pattern 170%

Geranium Worksheet

Double-load #12 flat brush
with Berry Wine and Crimson.

Petal
Using C-stroke, form petals
around flower.

Using handle end of
brush, dot center with
School Bus Yellow.

Leaf
Double-load brush with Green
Forest and Wicker White.

Using chisel edge of
brush, push, wiggle,
turn, and lift.

Side-load with inky
Crimson.

Float Crimson around inside of leaf.

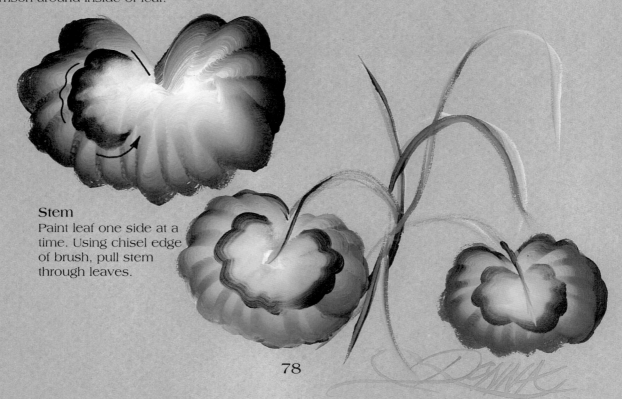

Stem
Paint leaf one side at a
time. Using chisel edge
of brush, pull stem
through leaves.

78

How to Paint Fruit

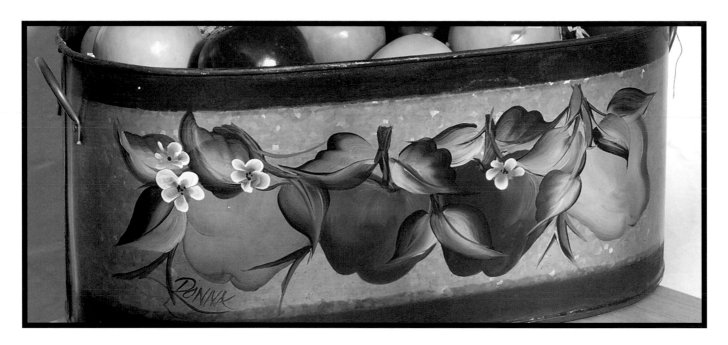

This chapter shows how to paint a variety of fruits, such as apples, blackberries, cherries, grapes, and strawberries. These rounded shapes are all done the same way, so once you learn how to paint one, the others will be a breeze. They all look so fresh, your family and friends will wish they were edible. Choose from a variety of projects, such as baskets, planters, plates, and trays.❋

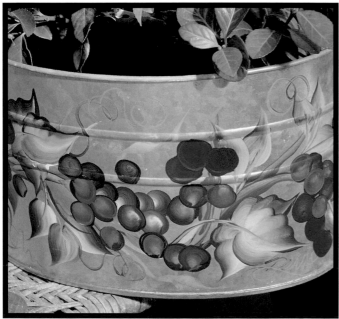

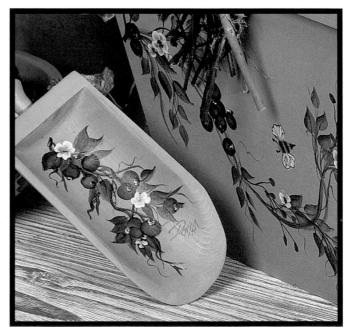

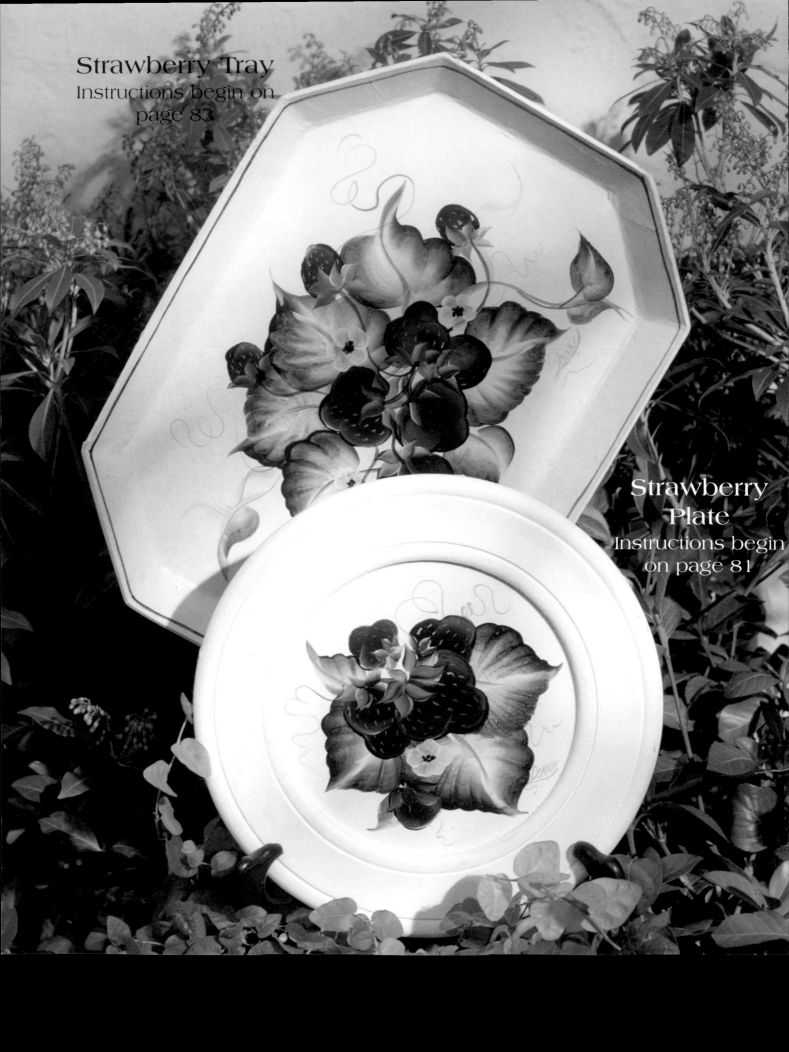

Strawberry Tray
Instructions begin on
page 83

**Strawberry
Plate**
Instructions begin
on page 81

Strawberry Plate

Pictured on page 80

GATHER THESE SUPPLIES

Painting Surface:
Wooden plate, 10" dia.

Paints, Stains & Finishes:
Acrylic craft paints:
 Green Forest
 Napthol Crimson
 School Bus Yellow
 Wicker White
Matte acrylic sealer

Brushes:
Flat, ¾", #12
Liner, #2
Sponge brush

Other Supplies:
Sandpaper, 220 grit
Tack cloth
Tracing tool
Transfer tool

INSTRUCTIONS

Prepare:
1. Refer to General Instructions on pages 11–19. Using sandpaper, sand plate. Using tack cloth, wipe away dust.

2. Using sponge brush, basecoat plate with Wicker White. Let dry.

3. Using tracing and transfer tools, transfer Strawberry Plate Pattern onto plate.

Paint the Design:
Leaves:
1. Refer to Berry Worksheet on page 82. Using ¾" flat brush, paint leaves with Green Forest and School Bus Yellow.

Strawberries:
1. Using #12 flat brush, paint strawberries with Napthol Crimson, School Bus Yellow, and Wicker White.

Blossoms:
1. Paint blossoms by making C-stroke flowers with School Bus Yellow and Wicker White.

Seeds:
1. Using #2 liner, paint seeds with Green Forest and Wicker White.

Bracts:
1. Using #12 flat brush, paint bracts with Green Forest and School Bus Yellow.

Curlicues & Name:
1. Using #2 liner, paint curlicues and sign your name with inky Green Forest.

Finish:
1. Apply matte acrylic sealer.✳

Strawberry Plate Pattern

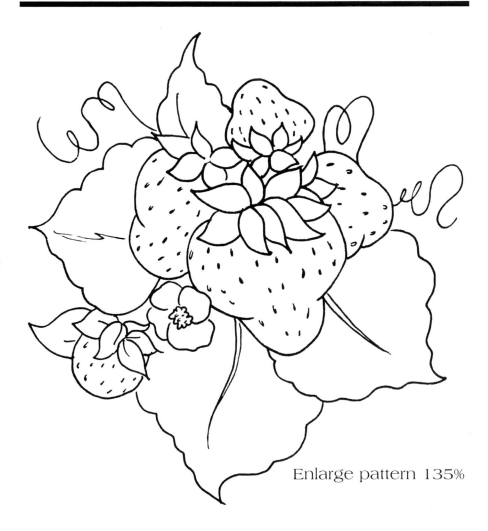

Enlarge pattern 135%

Berry Worksheet

Blueberry

Double-load #12 flat brush with Thunder Blue and Winter White.

 Using tip of #2 liner, paint dots with Wicker White.

Blackberry

Using #12 flat brush, basecoat blackberry with Thunder Blue. Paint small C-strokes for individual drupes with Wicker White. Stagger drupes until area is full.

Reddish Blackberry

Using #12 flat brush, paint reddish blackberry with Berry Wine. Using chisel edge of #12 flat brush, paint bracts with Green Forest and School Bus Yellow.

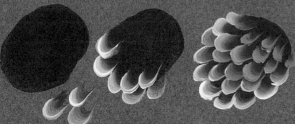

Curlicue

Using #2 liner, paint curlicue with inky Green Forest.

Strawberry

Double-load #12 flat brush with Crimson and School Bus Yellow. Paint right side of strawberry with Crimson and Wicker White.

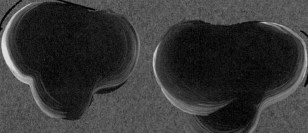

New Berry

Double-load #12 flat brush with Crimson and School Bus Yellow.

Seed

Double-load #2 liner with Green Forest and Wicker White.

Leaf

Double-load #12 flat brush with Green Forest and School Bus Yellow.

Bract

Double-load #12 flat brush with Green Forest and Wicker White.

Blossom

Using #12 flat brush, paint blossoms with School Bus Yellow.

Strawberry Tray

Pictured on page 80

GATHER THESE SUPPLIES

Painting Surface:
Papîer maché octagonal tray,
 15" x 11"

Paints, Stains & Finishes:
Acrylic craft paints:
 Green Forest
 Napthol Crimson
 School Bus Yellow
 Wicker White
Matte acrylic sealer
Spray paint: Wicker White

Brushes:
Flat, ¾", #12
Liner, #2

Other Supplies:
Tack cloth
Tracing tool
Transfer tool

INSTRUCTIONS

Prepare:
1. Refer to General Instructions on pages 11–19. Using #12 flat brush, base-coat tray with Wicker White spray paint.

2. Using tracing and transfer tools, transfer Strawberry Tray Pattern onto tray.

Paint the Design:
Leaves:
1. Refer to Berry Worksheet on page 82. Using ¾" flat brush, paint leaves with Green Forest and School Bus Yellow.

Strawberries:
1. Using #12 flat brush, paint strawberries with Napthol Crimson, School Bus Yellow, and Wicker White.

Blossoms:
1. Paint berry blossoms by making C-stroke flowers with School Bus Yellow and Wicker White.

Seeds:
1. Using #2 liner, paint seeds with Green Forest and Wicker White.

Bracts:
1. Using #12 flat brush, paint bracts with Green Forest and School Bus Yellow.

Curlicues & Name:
1. Using #2 liner, paint curlicues and sign your name with inky Green Forest.

Finish:
1. Using #2 liner, paint a ⅛" thick border around inside edge of tray with Green Forest. The border should be ¼" from inside of tray edge.

2. Apply matte acrylic sealer.✳

Strawberry Tray Pattern

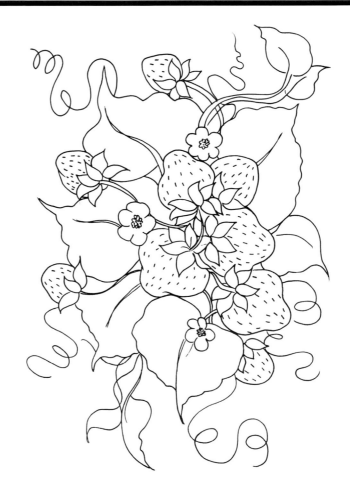

Enlarge pattern 230%

83

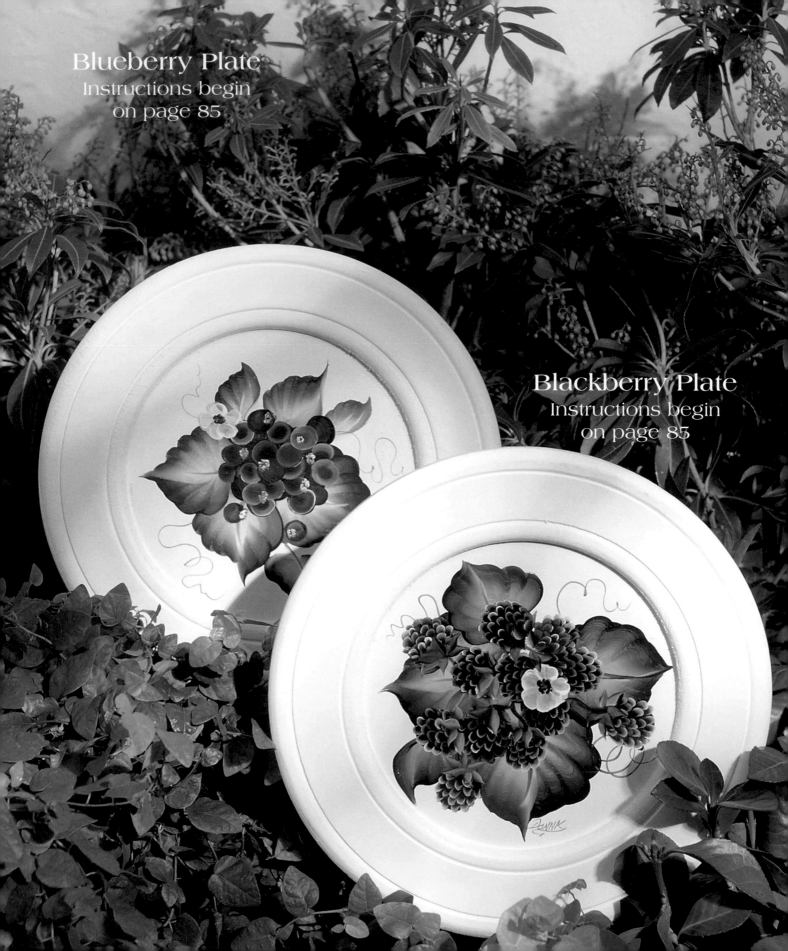

Blueberry Plate
Instructions begin on page 85

Blackberry Plate
Instructions begin on page 85

Blueberry Plate

Pictured on page 84

GATHER THESE SUPPLIES

Painting Surface:
Wooden plate, 10" dia.

Paints, Stains & Finishes:
Acrylic craft paints:
 Green Forest
 School Bus Yellow
 Thunder Blue
 Wicker White
 Winter White
Matte acrylic sealer

Brushes:
Flat, ¾"
Liner, #2
Sponge brush

Other Supplies:
Sandpaper, 220 grit
Tack cloth
Tracing tool
Transfer tool

INSTRUCTIONS

Prepare:
1. Refer to General Instructions on pages 11–19. Using sandpaper, sand plate. Using a tack cloth, wipe away dust.

2. Using sponge brush, base-coat plate with Wicker White. Let dry.

3. Using tracing and transfer tools, transfer Blueberry Plate Pattern on page 86 onto plate.

Paint the Design:
Leaves:
1. Refer to Berry Worksheet on page 82. Using ¾" flat brush, paint leaves with Green Forest and School Bus Yellow.

Blueberries:
1. Paint blueberries with Thunder Blue and Winter White.

2. Using #2 liner, dot blueberries with Wicker White.

Blossoms:
1. Paint C-stroke with School Bus Yellow and Wicker White.

2. Using handle end of brush, dot centers of blossoms with Green Forest.

Curlicues & Name:
1. Using #2 liner, paint curlicues and sign name with inky Green Forest.

Finish:
1. Apply matte acrylic sealer.✳

Blackberry Plate

Pictured on page 84

GATHER THESE SUPPLIES

Painting Surface:
Wooden plate, 10" dia.

Paints, Stains & Finishes:
Acrylic craft paints:
 Berry Wine
 Green Forest
 School Bus Yellow
 Thunder Blue
 Wicker White
Matte acrylic sealer

Brushes:
Flat, ¾", #12
Liner, #2
Sponge brush

Other Supplies:
Sandpaper, 220 grit
Tack cloth
Tracing tool
Transfer tool

INSTRUCTIONS

Prepare:
1. Refer to General Instructions on pages 11–19. Using sandpaper, sand plate. Using tack cloth, wipe away dust.

2. Using sponge brush, base-coat plate with Wicker White. Let dry.

3. Using tracing and transfer tools, transfer Blackberry Plate Pattern on page 86 onto plate.

Paint the Design:
Leaves:
1. Refer to Berry Worksheet on page 82. Using ¾" flat brush, paint leaves with Green Forest and School Bus Yellow.

Blackberries:
1. Base-coat blackberries with Thunder Blue. For reddish blackberries, use Berry Wine.

2. Using #12 flat brush, paint small C-strokes for individual drupes with Wicker White.

Bracts:
1. Paint bracts with Green Forest and School Bus Yellow.

Blossoms:
1. Make C-strokes to form blossoms with School Bus Yellow and Wicker White.

2. Using handle end of brush, dot centers with Green Forest.

Curlicues & Name:
1. Using #2 liner, paint curlicues and sign your name with inky Green Forest. Let dry.

Finish:
1. Apply matte acrylic sealer.✳

Blueberry Plate Pattern

Enlarge pattern 200%

Blackberry Plate Pattern

Enlarge pattern 200%

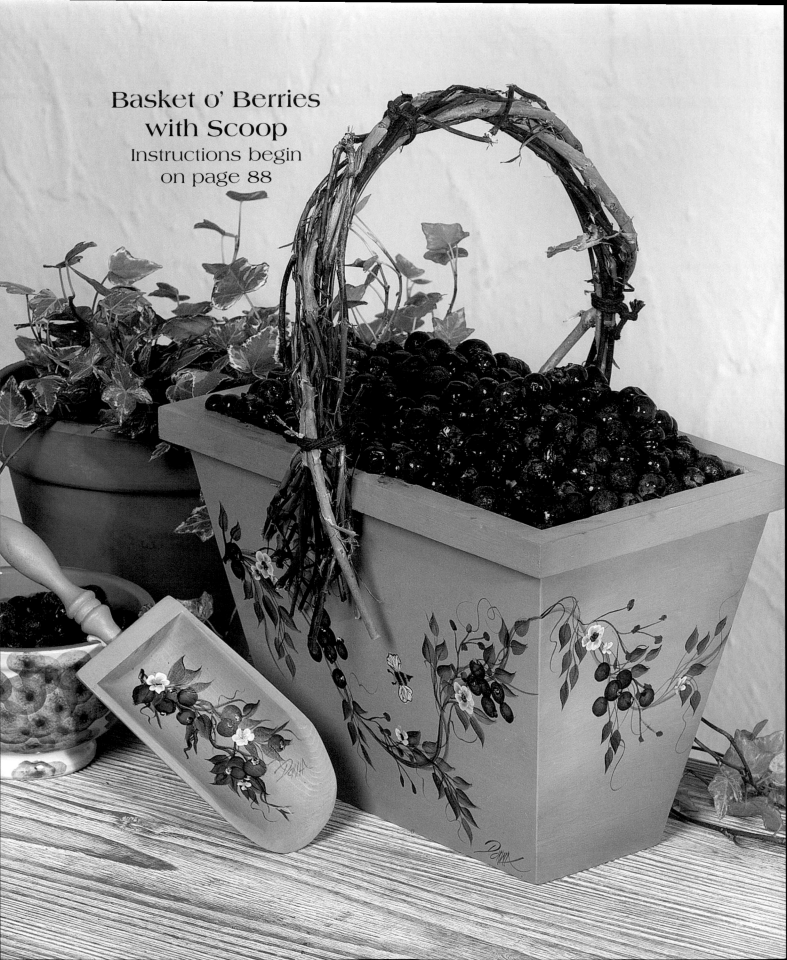

Basket o' Berries
with Scoop
Instructions begin
on page 88

Basket o' Berries with Scoop

Pictured on page 87

GATHER THESE SUPPLIES

Painting Surface:
Wooden basket with vine-covered wire handle,
11" x 7" x 8"
Wooden scoop

Paints, Stains & Finishes:
Acrylic craft paints:
 Barn Wood
 Berry Wine
 Burnt Umber
 Licorice
 Midnight
 Olive Green
 Wicker White
 Yellow Ochre
Matte acrylic sealer

Brushes:
Flat, #2, #6
Liner, #1

Other Supplies:
Sandpaper, 220 grit
Tack cloth
Tracing tool
Transfer tool

INSTRUCTIONS

Prepare:
1. Refer to General Instructions on pages 11–19. Using sandpaper, sand basket and scoop. Using tack cloth, wipe away dust.

2. Using #2 flat brush, base-coat basket and scoop with Barn Wood. Let dry.

3. Using tracing and transfer tools, transfer Basket o' Berries Back, Front, Side, and Scoop Patterns on pages 88-90 onto basket and inside of scoop.

Paint the Design:
Vines:
1. Refer to Small Blueberry Worksheet on page 90. Using chisel edge of #6 flat brush, paint vines around basket with Burnt Umber and Wicker White.

Leaves:
1. Paint leaves with Burnt Umber and Olive Green.

2. Using #1 liner, paint stems of leaves with Burnt Umber.

Flowers:
1. Using #6 flat brush, paint petals with Wicker White.

2. Paint centers with Burnt Umber and Yellow Ochre.

Small Berries:
1. Using #2 flat brush, make small berries with Berry Wine.

Blueberries:
1. Paint blueberries with Midnight. For some blueberries, pick up a small amount of Wicker White on corner of same brush and lightly touch tip to blueberry.

Curlicues & Name:
1. Using #1 liner, paint curlicues and sign your name with inky Burnt Umber.

Bumble Bee:
1. Using #6 flat brush, base-coat bee's wings with Wicker White.

2. Base-coat bee's body with Yellow Ochre.

3. Using #1 liner, paint body stripes, antennae and wing detail with inky Licorice.

4. Using tip of handle end of brush, dot ends of antennae with Licorice.

Finish:
1. Apply matte acrylic sealer.✻

Basket o' Berries Scoop Pattern

Pattern is actual size

Basket o' Berries Back Pattern

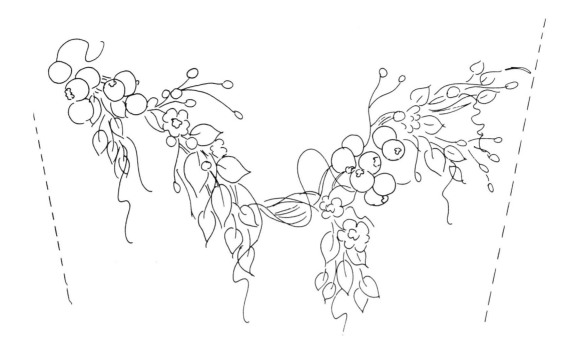

Basket o' Berries Front Pattern

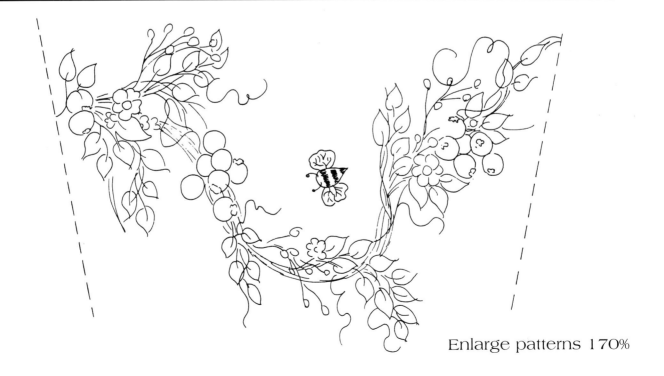

Enlarge patterns 170%

Small Blueberry Worksheet

Vine
Double-load #6 flat brush with Burnt Umber and Wicker White.

Using #2 liner, add curlicues with inky Burnt Umber.

Flower
Using #6 flat brush, paint flower with Wicker White. Dot center with Burnt Umber and Yellow Ochre. Using #2 liner, make center lines with inky Burnt Umber.

Small Berry
Using #2 flat brush, make small tear-shaped strokes for each berry with Berry Wine.

Stem & Branch
Using #2 liner, paint with Burnt Umber.

Small Leaf
Using #2 liner, paint leaf with Olive Green.

Blueberry
Using #2 flat brush, paint blueberry with Midnight. Using corner of brush, dot seed spot on blueberry with Wicker White.

Curlicues & Branch
Using #2 liner, paint with inky Burnt Umber.

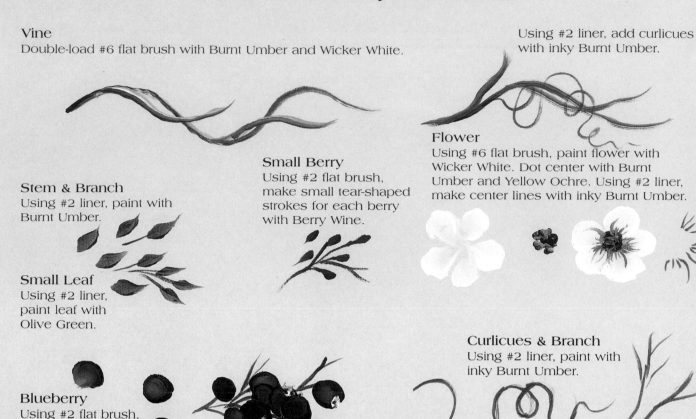

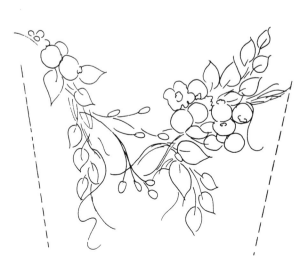

Basket o' Berries Side Patterns

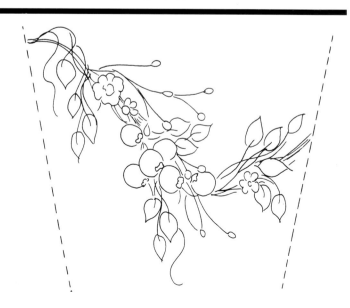

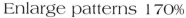

Enlarge patterns 170%

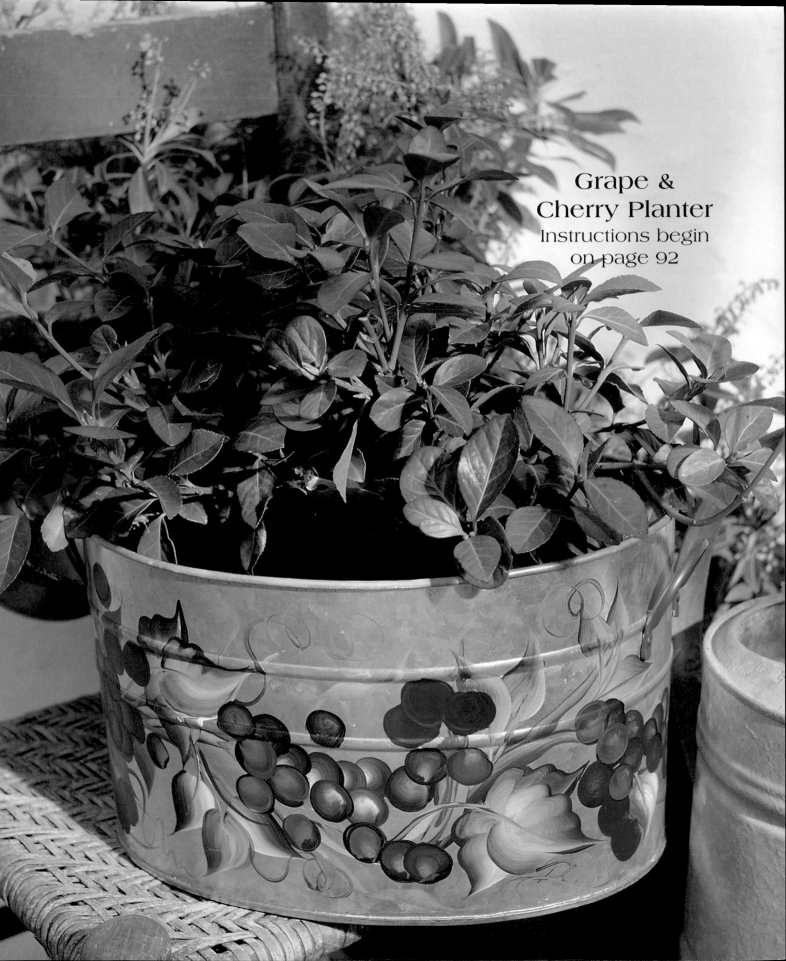

Grape &
Cherry Planter
Instructions begin
on page 92

Grape & Cherry Planter

Pictured on page 91

GATHER THESE SUPPLIES

Painting Surface:
Deep galvanized tin wash tub,
 13" x 11" x 7½"

Paints, Stains & Finishes:
Acrylic craft paints:
 Berry Wine
 Dark Brown
 Dioxazine Purple
 Green Forest
 Rose White
 School Bus Yellow
 Wicker White
Extra-thick glaze (glossy)

Brushes:
Flat, ¾", #12
Liner, #2

Other Supplies:
Clean cloth
Clean towel

Tracing tool
Transfer tool
Vinegar

INSTRUCTIONS

Prepare:
1. Refer to General Instructions on pages 11–19. Using a clean cloth dampened with vinegar and water, wipe oily residue off tin wash tub. Dry with clean towel.

2. Using tracing and transfer tools, transfer Grape & Cherry Planter Pattern onto one side of wash tub.

Paint the Design:
Stems:
1. Refer to Grape & Cherry Worksheet on page 93. Using #12 flat brush, paint stems with Dark Brown and Wicker White.

Leaves:
1. Using ¾" flat brush, paint leaves with Green Forest and Wicker White. Add a touch of School Bus Yellow to some of the leaves if desired.

Cherries:
1. Using #12 flat brush, paint cherries with Lipstick Red and Wicker White.

Cherry Stems:
1. Using chisel edge of brush, paint cherry stems with Green Forest.

Grapes:
1. Paint grapes with Dioxazine Purple and Rose White.

2. Paint reddish grapes with Dioxazine Purple and Berry Wine.

Curlicues & Name:
1. Using #2 liner, paint curlicues and sign your name with inky Green Forest.

Finish:
1. Apply extra-thick glaze.✷

Grape & Cherry Planter Pattern

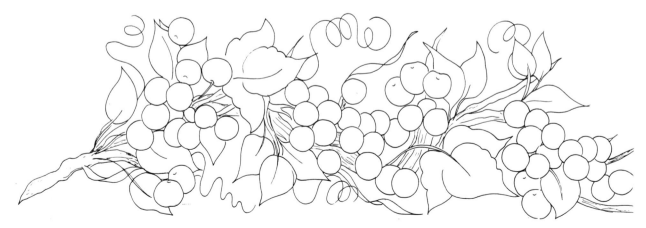

Enlarge pattern 300%

Grape & Cherry Worksheet

Cherry
Double-load #12 flat brush with Berry Wine and Wicker White.

Using C-stroke, paint left half of cherry.

Then paint right half of cherry.

Using chisel edge of brush, paint stems with Green Forest.

Grape
Double-load #12 flat brush with Dioxazine Purple and Rose White.

 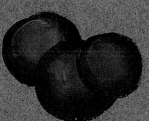

Reddish Grape
Double-load #12 flat brush with Berry Wine and Dioxazine Purple.

Leaf
Double-load ¾" flat brush with Green Forest and Wicker White. Add a touch of School Bus Yellow if desired.

Stem
Double-load #12 flat brush with Dark Brown and Wicker White.

Multiple Leaves
Double-load #12 flat brush with Green Forest and Wicker White.

93

DONNA

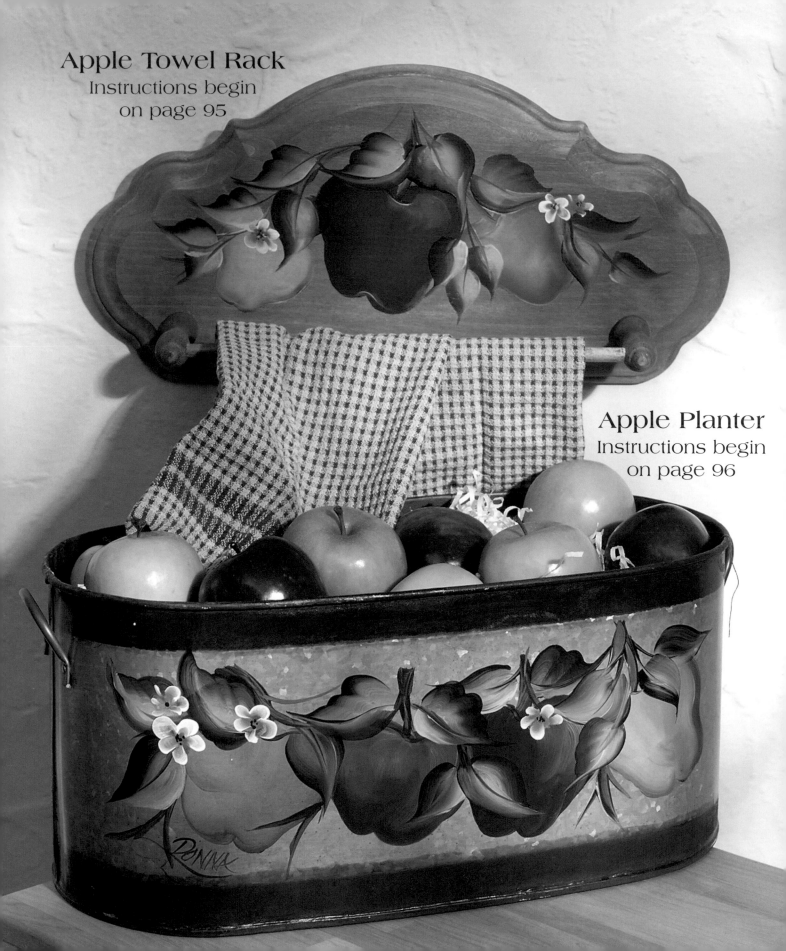

Apple Towel Rack
Instructions begin
on page 95

Apple Planter
Instructions begin
on page 96

Apple Towel Rack

Pictured on page 94

GATHER THESE SUPPLIES

Painting Surface:
Wooden towel rack, 18" x 9"

Paints, Stains & Finishes:
Acrylic craft paints:
 Dark Brown
 Engine Red
 Green Forest
 School Bus Yellow
 Wicker White
Antiquing medium:
 Apple Butter Brown
Matte acrylic sealer

Brushes:
Flat, ¾", #12
Liner, #2

Other Supplies:
Sandpaper, 220 grit
Tack cloth
Tracing tool
Transfer tool

INSTRUCTIONS

Prepare:
1. Refer to General Instructions on pages 11–19. Using sandpaper, sand towel rack. Using tack cloth, wipe away dust.

2. Stain with Apple Butter Brown antiquing medium. Let dry.

3. Using tracing and transfer tools, transfer Apple Towel Rack Pattern onto towel rack.

Paint the Design:
Apples:
1. Refer to Apple Worksheet #1 on page 97. Using ¾" flat brush, paint red apples with Dark Brown and Engine Red.

2. Paint green apple with Green Forest and School Bus Yellow.

3. Paint yellow apple with Green Forest and School Bus Yellow.

Leaves & Stems:
1. Paint leaves with Green Forest and School Bus Yellow.

2. Using #2 liner, paint stems with Green Forest.

Blossoms:
1. Using #12 flat brush, paint blossoms with School Bus Yellow and Wicker White.

2. Using handle end of brush, dot centers of blossoms with Green Forest.

Finish:
1. Apply matte acrylic sealer.❋

Apple Towel Rack Pattern

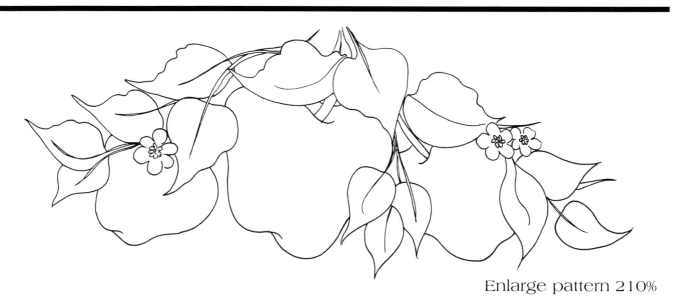

Enlarge pattern 210%

Apple Planter

Pictured on page 94

GATHER THESE SUPPLIES

Painting Surface:
Oval tin planter, 17¾" x 9" x 8"

Paints, Stains & Finishes:
Acrylic craft paints:
 Dark Brown
 Engine Red
 Green Forest
 School Bus Yellow
 Wicker White
Matte acrylic sealer

Brushes:
Flat, ¾", #12

Other Supplies:
Clean cloth
Clean towel
Tracing tool
Transfer tool
Vinegar

INSTRUCTIONS

Prepare:
1. Refer to General Instructions on pages 11–19. Using a clean cloth dampened with vinegar and water, wipe oily residue off tin planter. Dry with clean towel.

2. Using tracing and transfer tools, transfer Apple Planter Pattern onto tin planter.

Paint the Design:
Apples:
1. Refer to Apple Worksheets #1 and #2 on pages 97 and 98. Using ¾" flat brush, paint red apple with Dark Brown and Engine Red.

2. Paint green apple with Green Forest and School Bus Yellow.

3. Paint yellow apple with Green Forest and School Bus Yellow.

Leaves & Limbs:
1. Paint leaves with Green Forest and School Bus Yellow.

2. Using #12 flat brush, paint limbs with Dark Brown and Wicker White.

Blossoms:
1. Paint blossoms with School Bus Yellow and Wicker White.

2. Using handle end of brush, dot centers of blossoms with Green Forest.

Finish:
1. Apply matte acrylic sealer.❋

Apple Planter Pattern

Enlarge pattern 210%

Apple Worksheet #1

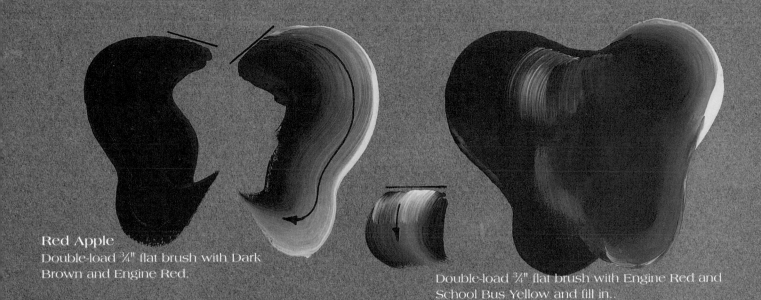

Red Apple
Double-load ¾" flat brush with Dark Brown and Engine Red.

Double-load ¾" flat brush with Engine Red and School Bus Yellow and fill in.

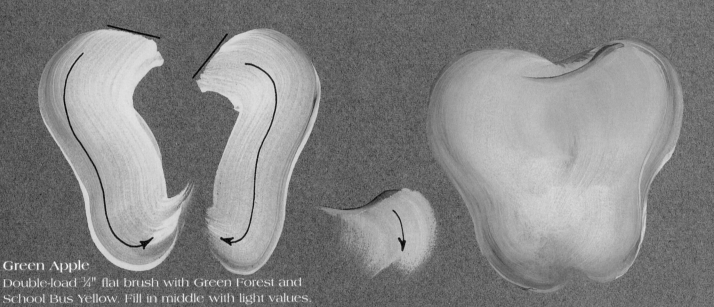

Green Apple
Double-load ¾" flat brush with Green Forest and School Bus Yellow. Fill in middle with light values.

Blossom
Double-load #12 flat brush with School Bus Yellow and Wicker White.

Paint enough overlapping C-strokes to complete a circle, forming flower.

Using tip of #1 liner, dot center with Green Forest.

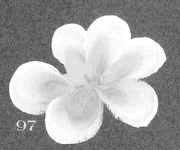
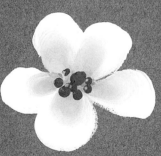

Apple Worksheet #2

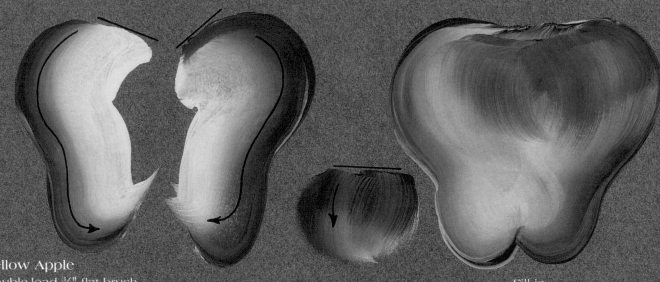

Yellow Apple
Double-load ¾" flat brush with Green Forest and School Bus Yellow.

Double-load ¾" flat brush with Berry Wine and School Bus Yellow.

Fill in.

Leaf
Double-load ¾" flat brush with Green Forest and School Bus Yellow.

Add vein with chisel edge.

Limb
Double-load ¾" flat brush with Dark Brown and Wicker White..

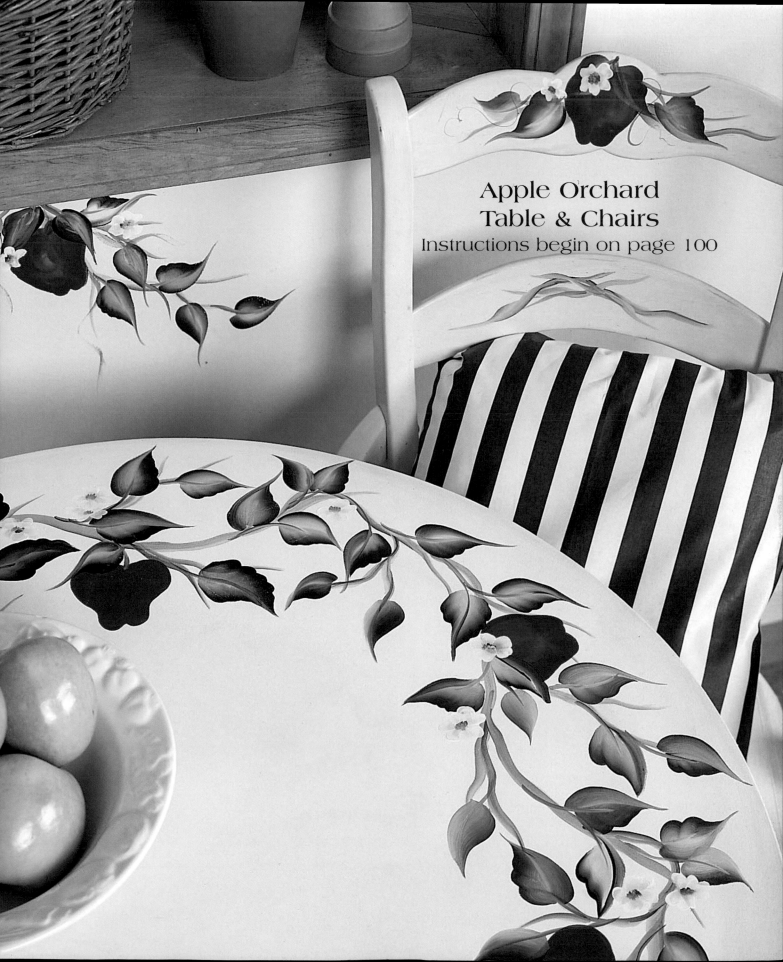

Apple Orchard
Table & Chairs
Instructions begin on page 100

Apple Orchard Table & Chairs

Pictured on page 99

GATHER THESE SUPPLIES

Painting Surface:
Metal table base
Round wooden tabletop
Wooden chairs

Paints, Stains & Finishes:
Acrylic craft paints:
 Berry Wine
 Green Forest
 Maple Syrup
 Napthol Crimson
 School Bus Yellow
 Wicker White
 Yellow Ochre
Latex paint: pale yellow
Matte acrylic sealer
Spray paint: black
White primer

Brushes:
Flat, ¾", #12
Liner, #2

Other Supplies:
Natural sponge
Sandpaper, 220 grit
Tack cloth
Tracing tool
Transfer tool

INSTRUCTIONS

Prepare:

1. Refer to General Instructions on pages 11–19. Remove seats from chairs. Using sandpaper, sand chairs and tabletop. Using a tack cloth, wipe away dust.

2. Apply white primer to chairs and tabletop, following manufacturer's instructions. Let dry. If grain is raised, sand smooth. Wipe away dust.

3. Using #12 flat brush, basecoat chairs and tabletop with pale yellow latex paint. Let dry.

4. Using damp natural sponge, sponge table and chairs with Yellow Ochre. Concentrate on edges, to create an antique look. Let dry.

5. Apply black spray paint to table base.

6. Refer to Apple Worksheets #1 and #2 on pages 97 and 98. Using tracing and transfer tools, create your own pattern to fit your table and chairs by transferring apple shapes onto tabletop and chair backs.

Paint the Design:
Branches:

1. Using ¾" flat brush, paint branches with Maple Syrup and Wicker White.

Apples:

1. Paint apples with with Berry Wine and Napthol Crimson. Pick up a touch of School Bus Yellow on Napthol Crimson edge.

Leaves:

1. Paint leaves with Green Forest and School Bus Yellow.

Blossoms:

1. Using #12 flat brush, paint blossoms with School Bus Yellow and Wicker White. Using handle end of brush, dot centers with Green Forest and School Bus Yellow.

Curlicues & Name:

1. Using #2 liner, paint curlicues and sign your name with inky Green Forest. Let dry.

Finish:

1. Apply matte acrylic sealer to tabletop and chairs. Let dry.

2. Assemble table. Reattach seats to chairs.✳

Painting for Christmas

In this chapter choose from a number of beautiful projects to light up your home during the holiday season. Whether you like the elegant look of poinsettias, magnolias and holly, or want the festive look of snowmen and jolly old Saint Nick, there is something to make your holidays special. You will also learn how to paint on glass to create shimmering holiday accent pieces.✳

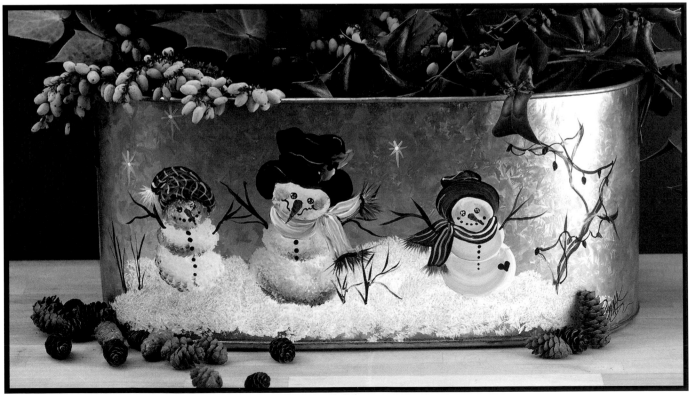

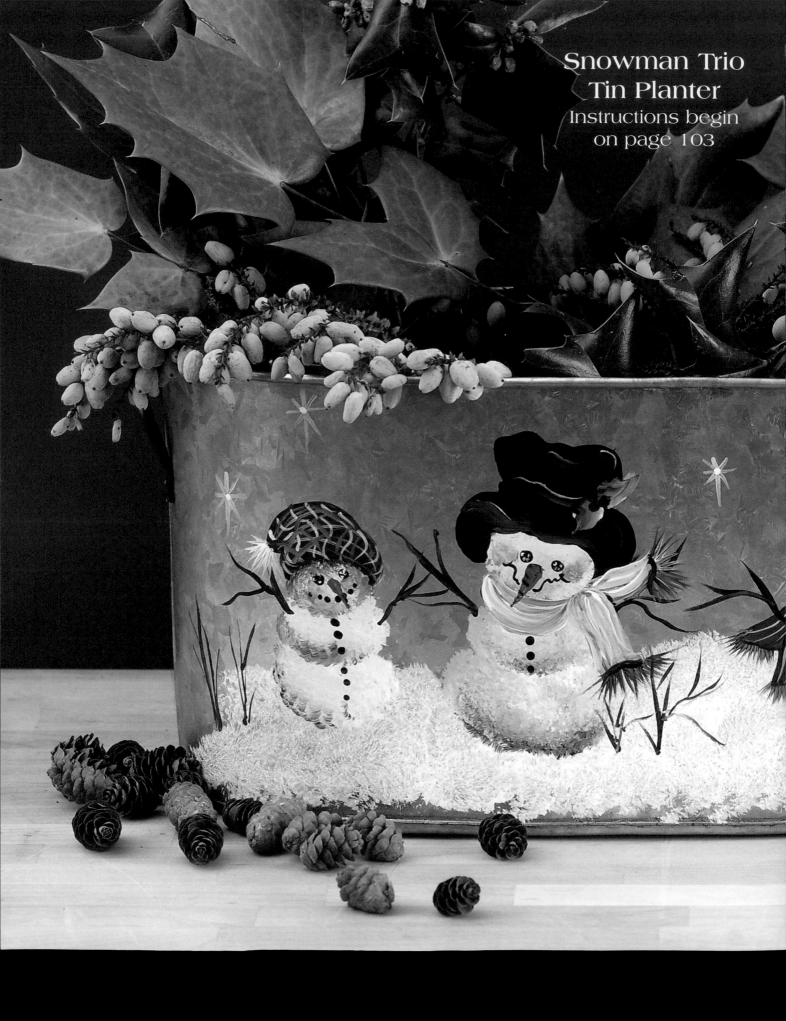

Snowman Trio
Tin Planter
Instructions begin
on page 103

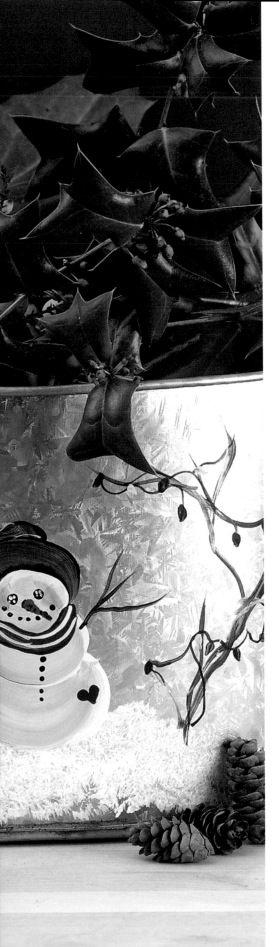

Snowman Trio Tin Planter

Pictured on page 102

GATHER THESE SUPPLIES

Painting Surface:
Tin planter, 8" x 18" x 9"

Paints, Stains & Finishes:
Acrylic craft paints:
 Butter Pecan
 Green Forest
 Licorice
 Maple Syrup
 Napthol Crimson
 Night Sky
 Pure Orange
 School Bus Yellow
 Wicker White
Matte acrylic sealer

Brushes:
Flat, #12
Liner, #2
Scruffy brush

Other Supplies:
Clean cloth
Clean towel
Tack cloth
Tracing tool
Transfer tool
Vinegar

INSTRUCTIONS

Prepare:
1. Refer to General Instructions on pages 11–19. Using a clean cloth dampeed with vinegar and water, wipe oily residue off tin planter. Dry with clean towel.

2. Using tracing and transfer tools, transfer Snowman Trio Tin Planter Pattern on page 104 onto planter.

Paint the Design:
Snow:
1. Refer to Scruffy Brush Worksheet on page 18. Using a scruffy brush, pounce snow for ground with Wicker White and a touch of Butter Pecan.

Snowmen:
1. Refer to Snowman Worksheet on page 105. Using #12 flat brush, paint smooth snowman with Wicker White and a touch of Butter Pecan.

2. Using scruffy brush, pounce fluffy snowmen with Maple Syrup and Wicker White.

3. Paint face and clothing for each snowman.

Branches:
1. Refer to Painting a Chisel-edged Branch on page 29. Using #12 flat brush, paint branches with Maple Syrup and Wicker White.

Stars:
1. Paint stars with School Bus Yellow and Wicker White.

Lights:
1. Using #2 liner, paint wire with Licorice. Alternate Green Forest, Napthol Crimson, Night Sky, and School Bus Yellow for lights.

Finish:
1. Apply matte acrylic sealer.✳

Snowman Trio Tin Planter Pattern

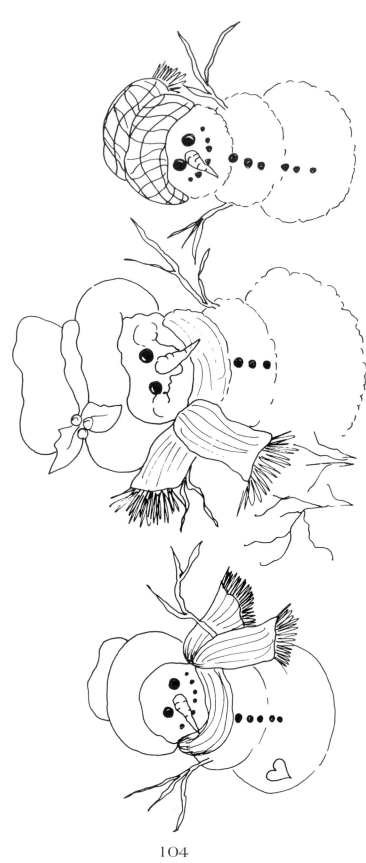

Enlarge pattern 150%

Snowman Worksheet

Fluffy Snowman
Using scruffy brush, pounce with Maple Syrup and Wicker White.

Smooth Snowman
Double-load #12 flat brush with Wicker White and a touch of Butter Pecan.

Hat
Double-load #12 flat brush with Licorice and Wicker White.

Dot Eyes
Using handle end of brush, dot eyes with Licorice.

Button Eyes
Using #2 liner, paint dots on dot eyes with Wicker White.

Cheeks
Using #12 flat brush, paint cheeks with Wicker White and a touch of Napthol Crimson.

Nose
Using #12 flat brush, paint nose with Pure Orange.

Dot Mouth
Using handle end of brush, dot mouth with Licorice.

Squiggly Mouth
Load #2 liner with Licorice.

Lights
Using #12 flat brush, paint wire with Licorice. Alternate Green Forest, Napthol Crimson, Night Sky, and School Bus Yellow for lights.

Scarf
Using #12 flat brush, paint scarf with Napthol Crimson or School Bus Yellow.

Tree
Using #2 liner, paint tree with Green Forest. Layer from bottom to top.

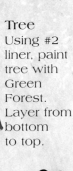

Buttons
Using handle end of brush, dot buttons with Licorice.

Dot Heart
Using handle end of brush, dot heart with Napthol Crimson.

Branches
Double-load #12 flat brush with Maple Syrup and Wicker White.

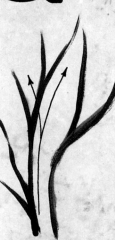

Hat
Using #12 flat brush, paint hat with Napthol Crimson. Using #2 liner, accent with Green Forest and Wicker White.

Fringe
Using #2 liner, paint fringe with Green Forest or Maple Syrup. Highlight with Wicker White.

105

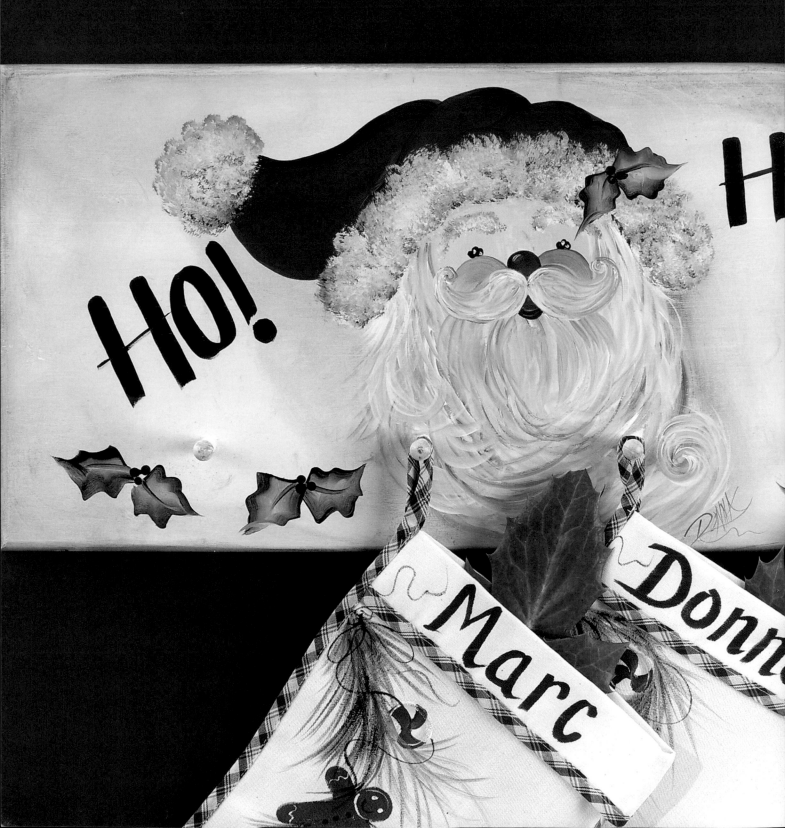

Jolly Santa Peg Rack
Instructions begin
on page 107

Jolly Santa Peg Rack

Pictured on page 106

GATHER THESE SUPPLIES

Painting Surface:
Wooden plaque with four pegs,
 1" x 11" x 24"

Paints, Stains & Finishes:
Acrylic craft paints:
 Berry Wine
 Butter Pecan
 Green Forest
 Licorice
 Maple Syrup
 Napthol Crimson
 Sunflower
 Tapioca
 Wicker White
Matte acrylic sealer

Brushes:
Flat, ¾", #12
Scruffy brush

Other Supplies:
Sandpaper, 220 grit
Sponge mitt
Tack cloth
Tracing tool
Transfer tool

INSTRUCTIONS

Prepare:
1. Refer to General Instructions on pages 11–19. Using sandpaper, sand plaque. Using tack cloth, wipe away dust.

2. Using #12 flat brush, basecoat plaque with Wicker White. Let dry.

3. Using sponge mitt, pounce with Butter Pecan, especially around edges. Make some areas darker than others.

4. Using tracing and transfer tools, transfer Jolly Santa Peg Rack Patterns on page 109 onto rack.

Paint the Design:
Face:
1. Refer to Santa Worksheet on page 108. Using ¾" flat brush, paint face with Mape Syrup and Tapioca.

Beard & Moustache:
1. Using chisel edge of brush, paint strokes from face downward into beard with Butter Pecan and Wicker White.

Stocking Cap:
1. Using ¾" flat brush, paint stocking cap with Berry Wine and Napthol Crimson.

2. Using scruffy brush, pounce fur onto cap with Wicker White. Reload brush with Maple Syrup and Wicker White and pounce onto fur for shading.

Holly & Berries:
1. Refer to Leaf & Holly Worksheet on page 118. Using #12 flat brush, paint holly with Green Forest and Sunflower.

2. Using handle end of #12 brush, make dot berries with Napthol Crimson.

Shading & Lettering:
1. Using ¾" flat brush, shade around Santa with Maple Syrup. Refer to photo as a guide.

2. Using #12 flat brush, paint letters with Licorice.

Finish:
1. Apply matte acrylic sealer.✳

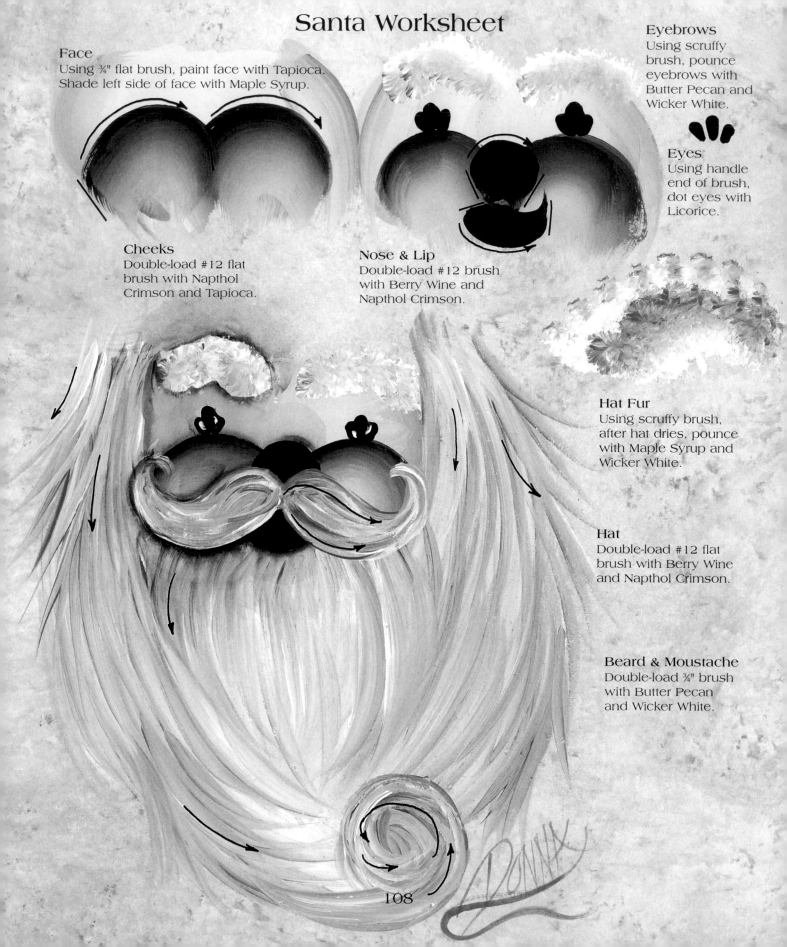

Santa Worksheet

Face
Using ¾" flat brush, paint face with Tapioca. Shade left side of face with Maple Syrup.

Eyebrows
Using scruffy brush, pounce eyebrows with Butter Pecan and Wicker White.

Eyes
Using handle end of brush, dot eyes with Licorice.

Cheeks
Double-load #12 flat brush with Napthol Crimson and Tapioca.

Nose & Lip
Double-load #12 brush with Berry Wine and Napthol Crimson.

Hat Fur
Using scruffy brush, after hat dries, pounce with Maple Syrup and Wicker White.

Hat
Double-load #12 flat brush with Berry Wine and Napthol Crimson.

Beard & Moustache
Double-load ¾" brush with Butter Pecan and Wicker White.

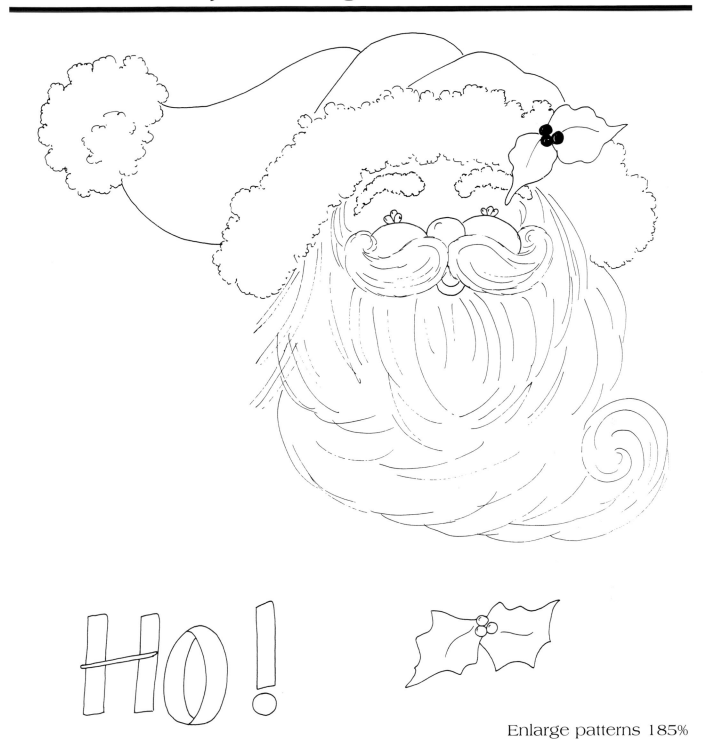

Enlarge patterns 185%

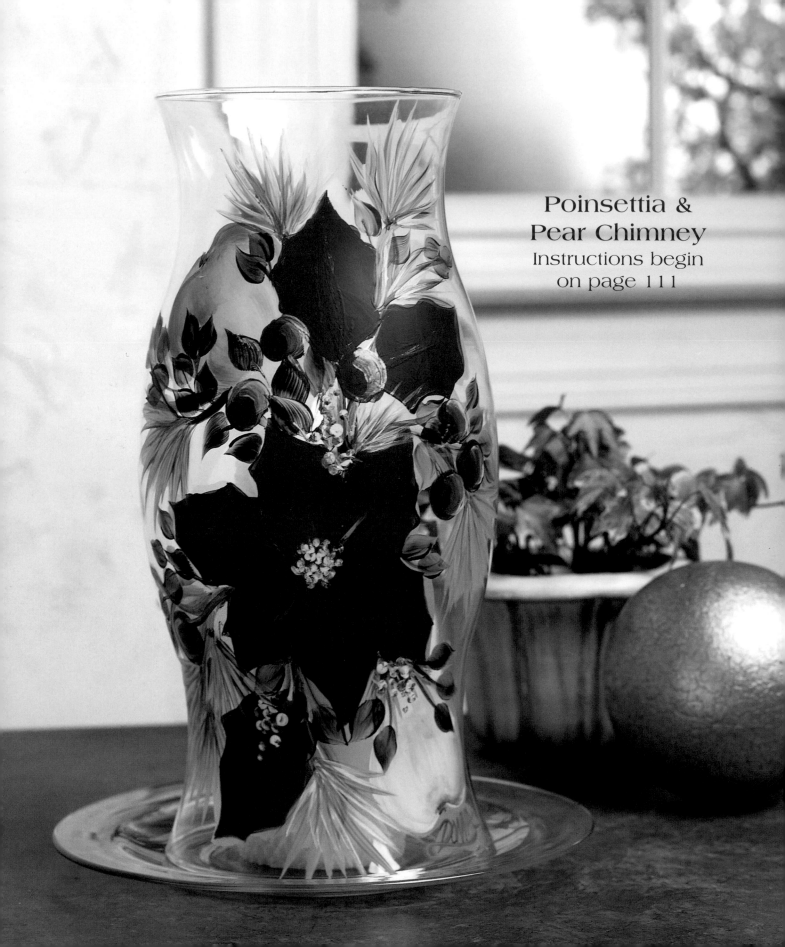

Poinsettia &
Pear Chimney
Instructions begin
on page 111

Poinsettia & Pear Chimney

Pictured on page 110

GATHER THESE SUPPLIES

Painting Surface:
Clear glass chimney, 11½" tall

Paints, Stains & Finishes:
Acrylic craft paints:
 Berry Wine
 Burnt Umber
 Green Forest
 Inca Gold
 Napthol Crimson
 Sunflower
 Wicker White
 Yellow Ochre
Glass & tile medium

Brushes:
Flat, #6, #12
Liner, #2

Other Supplies:
Clean cloth
Rubbing alcohol
Tracing tool
Transfer tool

INSTRUCTIONS

Prepare:
1. Refer to General Instructions on pages 11–19. Using a clean cloth dampened with rubbing alcohol, clean surface of glass.

2. Using tracing and transfer tools, transfer Poinsettia & Pear Chimney Pattern on page 112 onto glass chimney.

3. Refer to Painting on Glass and Glazed Ceramic Surfaces on page 12. Undercoat areas to be painted with glass & tile medium. Let dry.

Paint the Design:
Red Poinsettias:
1. Refer to Poinsettia & Magnolia Worksheet on page 113. Using #12 flat brush, paint red poinsettias with Berry Wine and Napthol Crimson.

Pears:
1. Paint left half of pear, following contours of the fruit, with Sunflower and Yellow Ochre, keeping Yellow Ochre to outer edge. Repeat on right half of pear.

2. Blend through middle of pear to join halves.

3. Paint stem ends on pears with Burnt Umber.

Branches:
1. Using chisel edge of brush, paint branches with Burnt Umber and Wicker White.

Leaves:
1. Refer to Poinsettia & Magnolia Worksheet on page 113. Using ¾" flat brush, paint leaves with Green Forest.

2. Paint some areas darker by picking up a small amount of Inca Gold.

Cherries:
1. Refer to Grape & Cherry Worksheet on page 93. Using #6 flat brush, paint cherries with Berry Wine and Napthol Crimson.

Pine Needles:
1. Using chisel edge of #12 flat brush, paint pine needles with Green Forest and Sunflower.

Poinsettia Centers:
1. Using handle end of #12 flat brush, make dots at center with Green Forest. Also make groups of dots throughout design. Refer to photo on page 110 as a guide.

2. Dot centers of flowers and groups of dots with School Bus Yellow, overlapping Green Forest dots. Let dry.

Highlights:
1. Using #6 flat brush, highlight cherries with Inca Gold.

2. Using #2 liner, highlight pine needles with Inca Gold.

Finish:
1. Apply glass & tile medium over painted designs. Let dry two weeks. ❋

Poinsettia & Pear Chimney Pattern

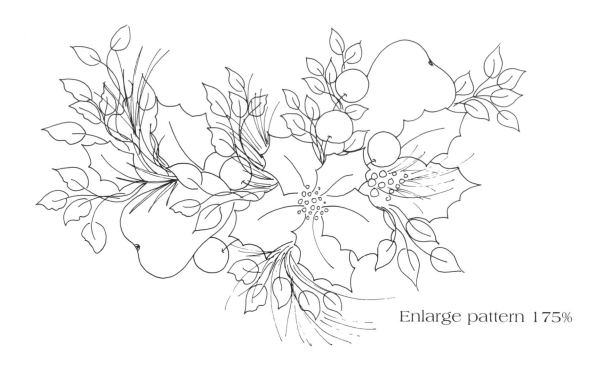

Enlarge pattern 175%

Magnolia Shelf Pattern

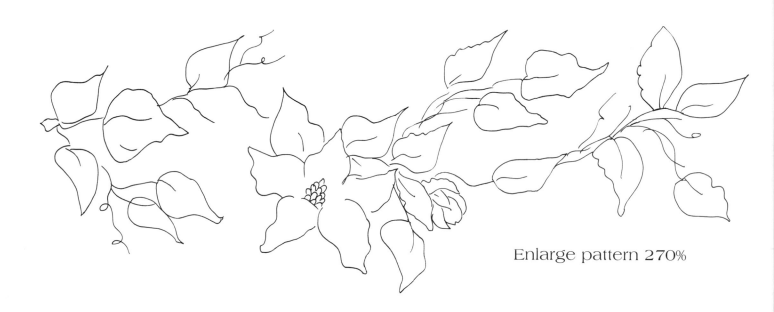

Enlarge pattern 270%

Poinsettia & Magnolia Worksheet

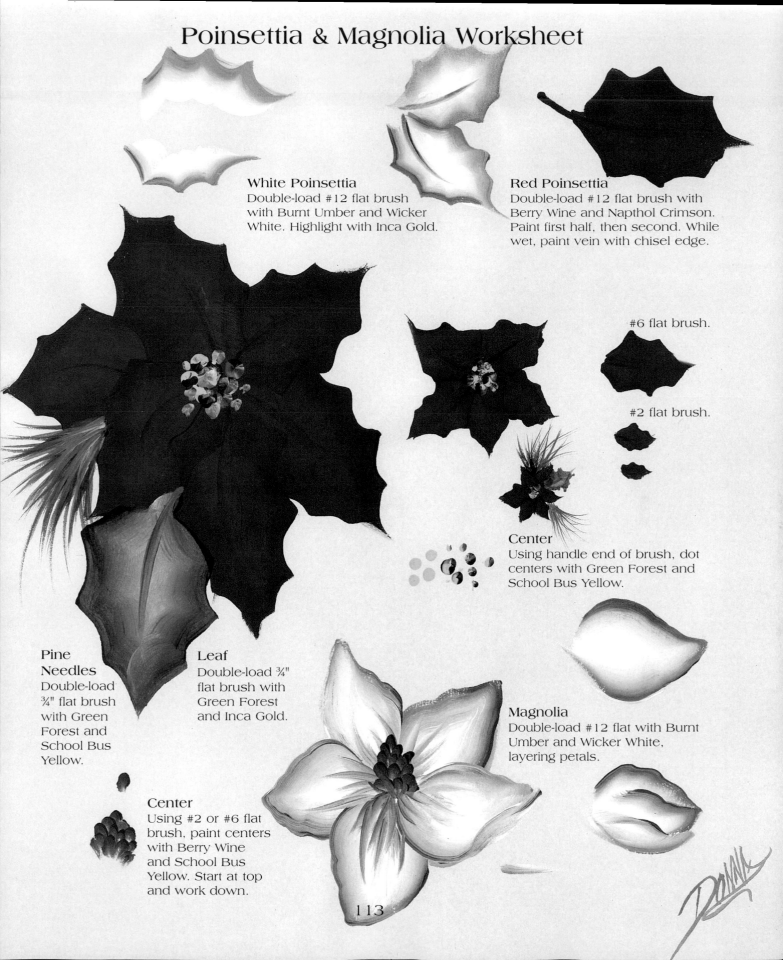

White Poinsettia
Double-load #12 flat brush with Burnt Umber and Wicker White. Highlight with Inca Gold.

Red Poinsettia
Double-load #12 flat brush with Berry Wine and Napthol Crimson. Paint first half, then second. While wet, paint vein with chisel edge.

#6 flat brush.

#2 flat brush.

Center
Using handle end of brush, dot centers with Green Forest and School Bus Yellow.

Pine Needles
Double-load ¾" flat brush with Green Forest and School Bus Yellow.

Leaf
Double-load ¾" flat brush with Green Forest and Inca Gold.

Magnolia
Double-load #12 flat with Burnt Umber and Wicker White, layering petals.

Center
Using #2 or #6 flat brush, paint centers with Berry Wine and School Bus Yellow. Start at top and work down.

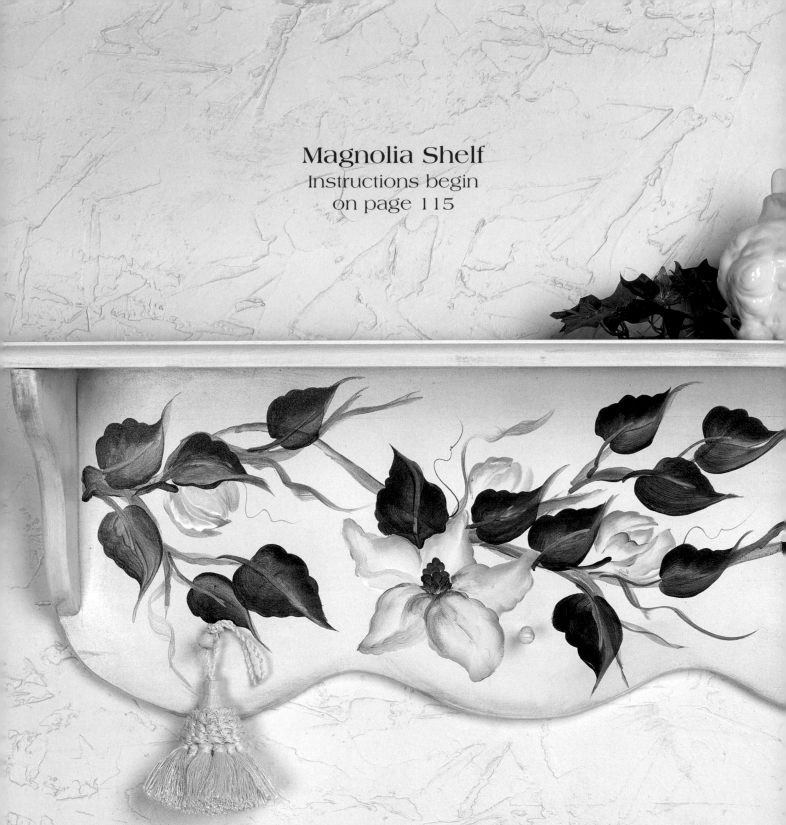

Magnolia Shelf
Instructions begin
on page 115

Magnolia Shelf

Pictured on page 114

GATHER THESE SUPPLIES

Painting Surface:
Wooden shelf

Paints, Stains & Finishes:
Acrylic craft paints:
 Berry Wine
 Burnt Umber
 Butter Pecan
 Green Forest
 Olive Green
 School Bus Yellow
 Wicker White
Matte acrylic sealer
White primer

Brushes:
Flat, ¾", #6, #12
Liner, #2

Other Supplies:
Natural sponge
Sandpaper, 220 grit
Tack cloth
Tracing tool
Transfer tool

INSTRUCTIONS

Prepare:
1. Refer to General Instructions on pages 11–19. Using sandpaper, sand wooden shelf. Using tack cloth, wipe away dust.

2. Apply white primer, following manufacturer's instructions. Let dry. If grain is raised, sand smooth. Wipe away dust.

3. Using #12 flat brush, basecoat shelf with Wicker White.

4. Using natural sponge, antique shelf with Butter Pecan on edges and in crevices. Refer to photo as a guide. Let dry.

5. Using tracing and transfer tools, transfer Magnolia Shelf Pattern on page 112 onto shelf.

Paint the Design:
Branches & Leaves:
1. Using chisel edge of #12 flat brush, paint branches with Burnt Umber.

2. Refer to Leaf Worksheet #1 on page 26. Paint Ruffle-edged Floral Leaf with Green Forest, Olive Green, and Wicker White.

Magnolia:
1. Refer to Poinsettia & Magnolia Worksheet on page 113. Using ¾" flat brush, paint magnolia blossom with Wicker White and a little Burnt Umber.

2. Using #6 flat brush, paint center of blossom with Berry Wine and School Bus Yellow.

Curlicues & Name:
1. Using #2 liner, add curlicues ans sign your name with inky Green Forest and inky Burnt Umber. Let dry.

Finish:
1. Apply matte acrylic sealer.✳

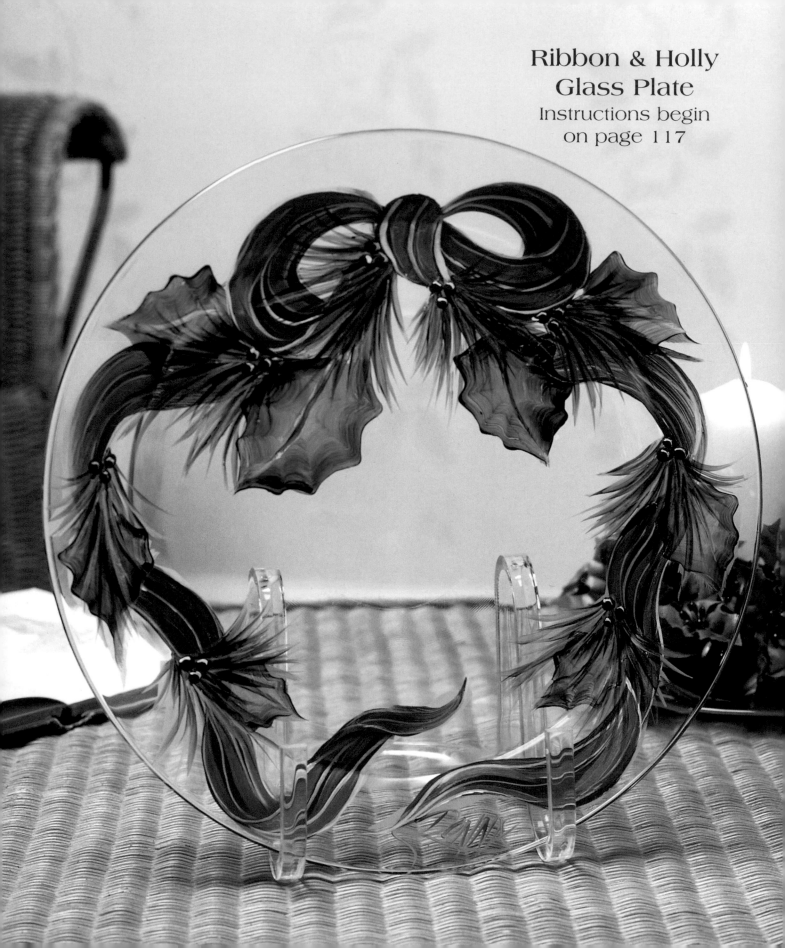

Ribbon & Holly
Glass Plate
Instructions begin
on page 117

Ribbon & Holly Glass Plate

Pictured on page 116

GATHER THESE SUPPLIES

Painting Surface:
Clear glass plate, 13" dia.

Paints, Stains & Finishes:
Acrylic craft paints:
 Berry Wine
 Green Forest
 Inca Gold
 Napthol Crimson
 School Bus Yellow
 Wicker White
Glass & tile medium

Brushes:
Flat, ¾", #12
Liner, #2

Other Supplies:
Clean cloth
Rubbing alcohol
Tracing tool
Transfer tool

INSTRUCTIONS

Prepare:
1. Refer to General Instructions on pages 11–19. Using a clean cloth dampened with rubbing alcohol, clean surface of glass.

2. Using tracing and transfer tools, transfer Ribbon & Holly Glass Plate Pattern on page 118 onto plate.

3. Refer to Painting on Glass and Glazed Ceramic on page 12. Undercoat areas to be painted with glass & tile medium. Let dry.

Paint the Design:
Bow:
1. Refer to Ribbon & Lace Worksheet on page 33. Using ¾" flat brush, paint bow and ribbon with Berry Wine and Napthol Crimson. Keep Berry Wine to outer edge. Let dry.

2. Using tip of #12 flat brush, paint gold stripes on bow with Inca Gold.

3. Using #2 liner, paint stripes on bow with Wicker White.

Greenery:
1. Refer to Leaf & Holly Worksheet on page 119. Using ¾" flat brush, paint holly leaves with Green Forest and School Bus Yellow.

2. Using chisel edge of #12 flat brush, paint pine needles with Forest Green and School Bus Yellow. Let dry.

3. Using #2 liner, highlight needles with Inca Gold.

Berries:
1. Using handle end of #12 flat brush, dot large berries, alternating with Berry Wine and Napthol Crimson.

2. Using handle end of #2 liner, dot small berries, alternating with Berry Wine and Napthol Crimson. Let dry.

3. Using a C-stroke motion, highlight berries on one side with Wicker White. Let dry.

Finish:
1. Apply glass & tile medium over painted designs. Let dry two weeks.✳

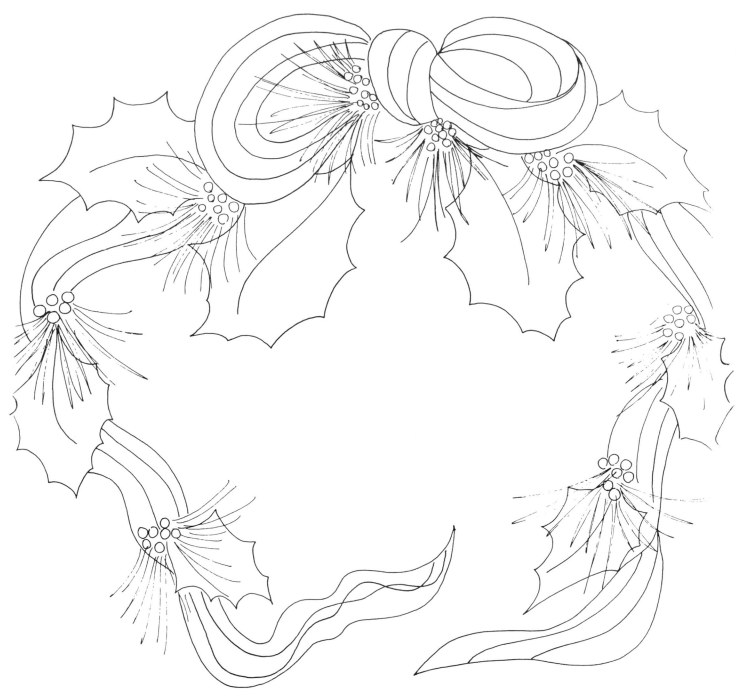

Pattern is actual size

Leaf & Holly Worksheet

One-stroke Leaf
Using #6 flat brush, paint leaf with Basil Green and Green Forest.

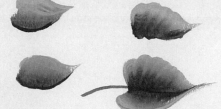

Branch
Double-load #12 flat brush with Burnt Umber and Wicker White.

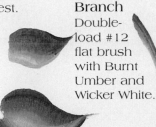

Small One-stroke Leaf
Using #2 flat brush, paint leaf with Green Forest. Using #2 liner, paint stems with inky Green Forest.

Vine
Using #2 liner, paint vine with inky Green Forest.

Two-stroke Leaf
Using #6 flat brush, paint leaf with Green Forest and School Bus Yellow.

Holly Leaf
Double-load #12 flat brush with Green Forest and School Bus Yellow.

Pine Needles
Double-load ¾" flat brush with Green Forest and School Bus Yellow.

Full Two-sided Leaf
Double-load ¾" flat brush with Green Forest and Inca Gold. Paint outer edge with Green Forest.

Curlicues
Using #2 liner, paint curlicues with inky Burnt Umber.

Thick Branch
Double-load #12 flat brush with Burnt Umber and Wicker White.

Ivy Leaf
Double-load ¾" flat brush with Green Forest and Inca Gold.

One-stroke Leaf
Double-load #12 flat brush with Green Forest and Inca Gold.

119

Decorating an Entire Room

Add life to bland rooms with hand–painted accents? This chapter shows how to bring a room to life by adding classic, decorative elements such as columns, flowering vines, urns, and window boxes—all with easy hand–painting! ❋

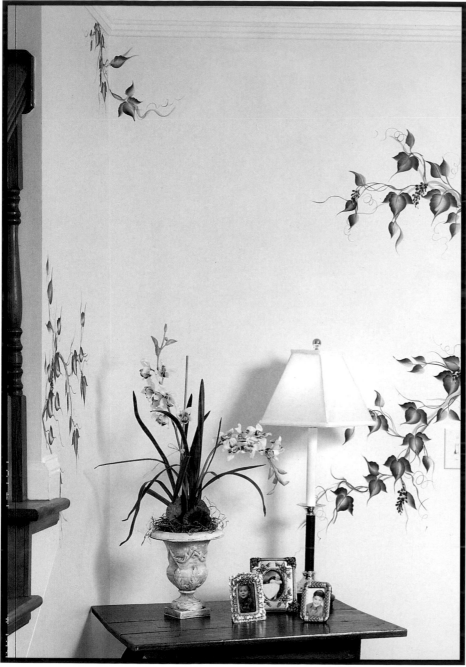

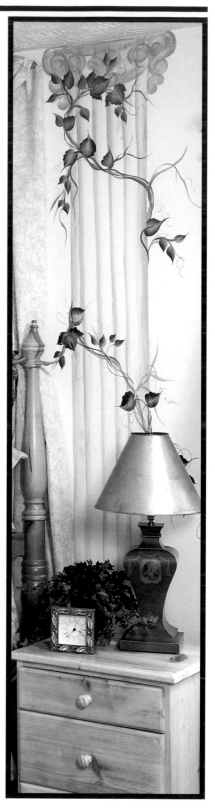

Room General Instructions

WALL PREPARATION

Before beginning be certain walls and woodwork are clean and free of dust, lint, grease, and wax. If walls and woodwork look dingy or have holes and cracks that need repairing, complete repairs and repaint before beginning.

USING DESIGNS

No patterns are provided giving you creative license. The designs are easy to freehand on walls—simply draw a vine on the wall with a pencil and begin painting your design along the vine line.

If you do not feel comfortable painting freehand, use one of the following options for transferring patterns onto walls:

Using Worksheets:
Create designs on tracing paper first. Simply trace design elements from appropriate worksheets in this book.

If painting a vine along the wall, draw a light vine pencil mark then transfer patterns onto wall with transfer paper.

To transfer, position pattern on wall and tape in place with masking tape. Place transfer paper between tracing and wall. Using a stylus, *lightly* trace pattern lines.

Using a projector:
With a projector, you can make a transparency of the design in the photo and project it on the wall. Sketch lines on wall with a pencil.

Enlarging designs:
Trace designs in photos of the rooms onto tracing paper. Then enlarge designs to fit walls. Once desired size is determined enlarge it on a copy machine.

Position enlarged pattern on wall and tape in place with masking tape. Place transfer paper between the photocopy and the wall. Using a stylus, *lightly* trace pattern lines.

You do not need to transfer every detail—it is more important to trace main outlines of the pattern.

Sketching designs freehand:
If you feel comfortable, you can simply use a pencil to lightly sketch designs on the wall. It is helpful to have the book or pattern propped up or taped up nearby to refer to while sketching.

Use worksheets from prior chapters as a guide for size. The elements on the worksheets are the actual size of the elements that are painted on the wall. For example, the ivy leaves on the Leaf & Vine Worksheet on page 30 are the actual size of those painted on the wall in the foyer.

Using a Sponge for Painting & Stenciling:
I like to use a household cellulose sponge for painting large areas and shapes and for stenciling. Always dampen sponge and squeeze out excess water before loading with paint. Squeeze paint on a disposable paper plate for loading.

•Painting large areas:
Load entire sponge. Pick up more than one color and use a generous amount of each color. Rub wall in a circular motion to fill area.

•Painting shapes:
Load sponge with dominant color, then stroke edge of sponge in shading color. Hold edge of sponge firmly with fingers and press on edge of sponge.

Using edge of sponge like a pencil, draw desired shape. Use this method when painting creases in clothing or folds or bends in bodies.

•Stenciling:
If using precut stencils, position stencil on wall, following manufacturer's instructions, and tape in place. Stroke sponge in color or colors specified. Stroke sponge in stencil openings.

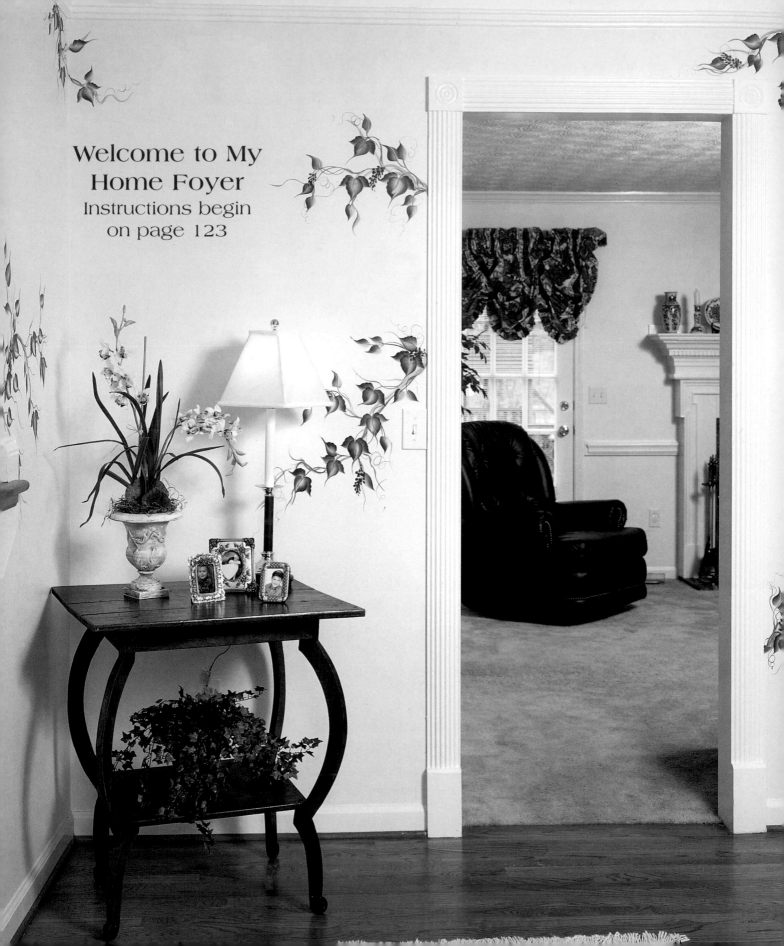

Welcome to My Home Foyer

Instructions begin
on page 123

Welcome to My Home Foyer

Pictured on page 122

Always make a statement in your foyer! It's the first thing people see when they enter your home. I like this room to have a light, tasteful accent that will flow to each room that adjoins it.

I positioned the branches and vines randomly to come out from the edges of door-ways and openings, giving the illusion that they are growing naturally all around you. This look is a lot more airy than some wallpapers.

Any flowers can be added to this vine. Here, I used trailing flowers, but you could use wisteria or roses or violets. Be creative, but be sure to coordinate the flower colors with colors in adjoining rooms so that they all flow together.

GATHER THESE SUPPLIES

Painting Surface:
As desired

Paints, Stains & Finishes:
Acrylic craft paints:
 Berry Wine
 Burnt Umber
 Green Forest
 Sunflower
 Wicker White

Brushes:
Flat, ¾", #12
Liner, #2

Other Supplies:
Tracing tool
Transfer tool

INSTRUCTIONS

Prepare:
1. Refer to Room General Instructions on page 121.

2. Using tracing and transfer tools, sketch design on wall. Because this design is simply a repetition of ivy leaves with a few flowers, it is best to simply sketch lines for the flowing vines, then paint leaves and flowers along lines.

Paint the Design:
Branches:
1. Refer to Leaf Worksheets #1 and #2 on pages 26 and 27.

2. Using chisel edge of ¾" flat brush, paint branches with Burnt Umber and Wicker White.

Vines:
1. Refer to Leaf & Vine Worksheet on page 30. Trail some vines from larger branches with Burnt Umber and Green Forest.

Leaves:
1. Add more Green Forest and Wicker White to the same brush. Paint leaves. Pick up some Sunflower on the Wicker White edge to give more color.

Flowers:
1. Using #12 flat brush, stroke petals of trailing flowers, making backward C-strokes with Berry Wine and Wicker White. Start at tip and layer petals to form clusters.

Curlicues:
1. Using #2 liner, add curlicues with inky Green Forest.✳

123

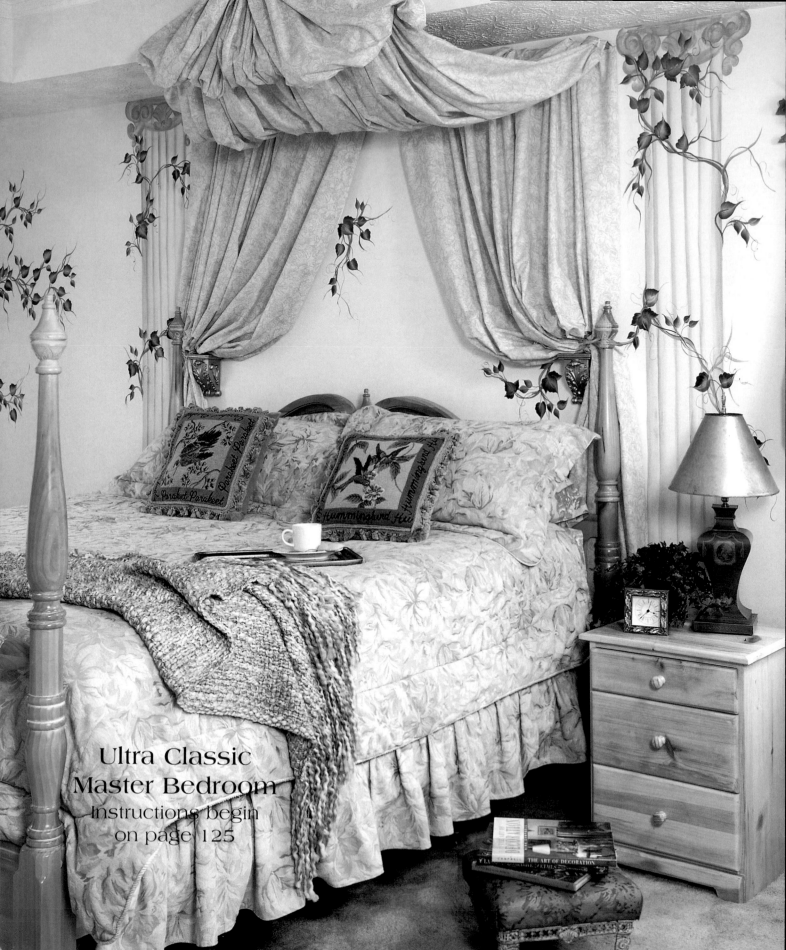

Ultra Classic
Master Bedroom
Instructions begin
on page 125

Ultra Classic Master Bedroom

Pictured on page 124

I wanted this room to be elegant yet simple, so I chose a classical, Old World look. As the room progressed, I decided I wanted the bed to be more of a focal point; the draped fabric helped achieve that. The fabric was inexpensive and the draping didn't require too much work. (My sister Kim, who has done this before, attached it, so it was really easy for me. Thanks, Kim!)

The tree in the urn is painted near a corner, so part of the tree's branches are on a facing wall. I added a window box above the dresser, using a stencil for the decorative window box.

GATHER THESE SUPPLIES

Painting Surface:
As desired

Paints, Stains & Finishes:
Acrylic craft paints:
 Berry Wine
 Burnt Umber
 Butter Pecan
 Green Forest
 Light Red Oxide
 Sunflower
 Wicker White
Floating medium

Brushes:
Flat, ¾", #6, #12
Liner, #2
Scruffy brush

Other Supplies:
Cellulose sponge
Measuring tape
Stencil, window box, precut
Tracing tool
Transfer tool

INSTRUCTIONS

Prepare:
1. Refer to Room General Instructions on page 121. Prepare desired painting surface.

Paint the Design:
Columns:
1. Using measuring tape, tracing and transfer tools, measure and lightly mark columns on wall, making as tall or wide as desired.

2. Using damp cellulose sponge, dip in Butter Pecan. Holding loaded edge of sponge, press sponge on wall from top to bottom, creating column lines. Continue until columns are complete, reloading sponge as needed. Let dry.

3. Using ¾" flat brush and floating medium, paint scrollwork on column capitals with Butter Pecan. Let dry.

Vines:
1. Paint vines around columns, placing them as they might naturally grow, with Burnt Umber and Wicker White, leading with Wicker White edge. Paint some branches that look like they are growing from draping behind bed.

Leaves:
1. Refer to Leaf Worksheets #1 and #2 on pages 26 and 27. Paint leaves with Green Forest and Sunflower.

Curlicues:
1. Using #2 liner, paint curlicues with inky Green Forest.

Urn:
1. Create pattern for urn as needed and transfer to wall. Refer to photo on page 20 as a guide.

2. Dampen cellulose sponge. Sideload sponge, dipping one edge in Butter Pecan. Holding loaded edge, press sponge on

wall along edges of urn. Rub sponge on wall in a circular motion inside urn shape.

3. Using ¾" flat brush and floating medium, paint top trim, handles, and details with Butter Pecan. Let dry.

4. Refer to Using a Scruffy Brush on page 17. Using scruffy brush, pounce moss with an up and down motion with Green Forest and Wicker White, occasionally picking up Butter Pecan.

5. Taper moss as if it is falling over edge of urn by leaning scruffy brush on side edge while pouncing. Let dry.

Tree:
1. Lightly sketch tree branches on wall. Refer to photo on page 20 as a guide.

2. Using ¾" flat brush, paint trunk and branches of tree with Burnt Umber and Wicker White, leading with Wicker White.

3. Refer to Leaf & Vine Worksheet on page 30. Paint vines and leaves at bottom of tree over mossy area with Green Forest and Sunflower.

4. Paint vines and leaves on and around tree branches, placing leaves facing in different directions for a natural, flowing look.

5. Using #12 flat brush, paint smaller leaves with Green Forest and Sunflower.

6. Using #2 liner, paint curlicues in greenery at base of tree with inky Green Forest.

Window Box:
1. Using window box stencil, lightly mark stencil on wall.

2. Using scruffy brush, pounce moss inside window box outline with Green Forest and Wicker White, occasionally picking up Butter Pecan. Let dry.

3. Position window box stencil over pounced moss. Pounce through openings in stencil to create wrought iron box with Berry Wine, Light Red Oxide, and Wicker White. Let dry.

Leaves:
1. Using ¾" flat brush, paint vines and leaves with Green Forest and Sunflower.

Flowers:
1. Using #6 flat brush, paint trailing flowers with Berry Wine and Wicker White.

Curlicues:
1. Using #2 liner, paint curlicues with inky Green Forest. ✳

Product Sources

Plaid Enterprises, Inc., Norcross, GA, produces high quality paint products that are formulated for decorative painting. Following are the product names and numbers:

FolkArt® Acrylic Paints:
404 Periwinkle
406 Hunter Green
416 Dark Brown
424 Light Gray
428 Rose White
429 Winter White
432 Sunflower
434 Berry Wine
436 Engine Red
440 Violet Pansy
441 Sterling Blue
443 Night Sky
445 Mint Green
447 Leaf Green
448 Green Forest
449 Olive Green
450 Parchment
602 Country Twill
609 Thunder Blue
645 Basil Green

726 Green Meadow
736 School Bus Yellow
753 Rose Chiffon
754 Rose Garden
901 Wicker White
903 Tapioca
936 Barn Wood
938 Licorice
939 Butter Pecan
945 Maple Syrup
964 Midnight

FolkArt® Metallic Colors:
676 Inca Gold

FolkArt® Artists' Pigments:
422 Portrait
462 Burnt Umber
463 Dioxazine Purple
486 Prussian Blue
628 Pure Orange
758 Alizarin Crimson
914 Light Red Oxide
917 Yellow Ochre

FolkArt® Painting Mediums:
Antiquing Medium Apple Butter Brown #819
Extender #947
Floating Medium #868
Glass & Tile Medium #869
Glazing Medium #893
Textile Medium #794

FolkArt® Finishes:
Acrylic Spray Sealer #788
Waterbase Varnish #791

Simply® Stencil Designs:
Following is the design used in this book:
Wrought Iron Window Box #26865

Index